TEXAS 100 Selections from the El Paso Museum of Art

TEXAS 100

Selections from the El Paso Museum of Art

FOREWORD AND INTRODUCTION

Becky Duval Reese

CONTRIBUTORS

Ben Fyffe

Christian John Gerstheimer

Amy Grimm

Kimberly McCarden

Nicholas Muñoz

Amy Beth Paoli

Becky Duval Reese

Michelle Dyan Ryden

EL PASO MUSEUM OF ART

In Association with the El Paso Museum of Art Foundation

This book is supported by a grant from the Summerlee Foundation,
the El Paso Museum of Art Foundation, and through funds provided by
the City of El Paso.

Published by the El Paso Museum of Art Foundation
Copyright © 2006 by the El Paso Museum of Art Foundation
1 Arts Festival Plaza, El Paso, Texas 79901

Production supervision by Michelle Dyan Ryden
Editing by Lucia Dura
Design by Jud Burgess/Substance
Photography by Marty Snortum Studio
Printed and bound in China by Sun Fung Offset Binding Co. Ltd.

The paper used in this publication meets the minimum requirements of
the American National Standard for Information Sciences – Permanence
of Paper for Printed Library Materials, ANSI Z39.48-1992.

Library of Congress Cataloging in Publication Data
Texas 100: Selections from the El Paso Museum of Art
Foreword and introduction by Becky Duval Reese
Writing contributions by Ben Fyffe, Christian John Gerstheimer,
Amy Grimm, Kimberly McCarden, Nicholas Muñoz, Amy Beth Paoli,
Becky Duval Reese, and Michelle Dyan Ryden

ISBN 0-9785383-0-7 (softcover/pbk:alk. paper):
1. Art, American – 20th Century – Handbooks, manuals, ect.
2. Art – Texas (State) – Handbooks, manuals, ect.
3. El Paso Museum of Art – Handbooks, manuals, ect.
I. Reese, Becky Duval
II. Title.

Dedicated to the artists.

In memory of Luis Jiménez.

FOREWORD

What a pleasure to review the past 30 years and to realize what an incredible privilege I have enjoyed. Since 1976, I have studied the art and artists of Texas. Beginning at the University of Texas Art Museum (subsequently known as the Huntington Art Gallery and now as the Jack S. Blanton Museum of Art) through the organization of pan-Texas exhibitions like "Made in Texas," "Images and Visions of Texas," and "A Century of Sculpture in Texas," I have studied and learned about the state's art and its history. I have met many of the state's artists, museum professionals, collectors, and gallery owners. I have written about Texas art, spoken about it, and have seen interest in collecting Texas art greatly expand. To bring my knowledge of art of the Lone Star state to this Museum and increase the holdings of Texas artists has been a wonderfully rewarding experience. I look back and am proud to see Texas artists widely respected, displayed and collected. I have always thought it important for people to know about and understand the art of their time and place. This publication of the Texas collection at the El Paso Museum of Art provides a 15-year snapshot of the art of 100 artists. I hope the work we began in 1991 goes forward and that the artists of our region continue to be recognized through exhibition and studied through publication.

Becky Duval Reese

The study of the art of Texas is as large an endeavor as the state itself. Since 1991, the El Paso Museum of Art has displayed, published and collected art created by Texas artists, and in so doing has become a strong repository for their work. Through this publication, the study of the state's artists and El Paso's holdings becomes more widely known.

In 1960, the El Paso Museum of Art was established with a gift of 57 works of European art from the Samuel H. Kress Foundation. The permanent collection continued to grow over the next 45 years with particular strengths in Mexican Colonial and American art. Today, the collection totals more than 5,000 objects. It is, however, within the past 15 years that numerous works by Texas artists have entered the Museum's collection providing an expansive focus on art of this region.

Beginning in 1991, quietly but methodically, the Museum began to showcase the region's artists. Exhibitions displayed a diverse grouping of artists, media, and styles that included Carmen Lomas Garza, Luis Jiménez, Ann Stautberg, James Surls, Susan Davidoff, Vincent Falsetta, Rachelle Thiewes, James Magee, Dan Rizzie, Willie Varela, Julie Bozzi, John Alexander, Ray Parish, Linda Ridgway, César Martínez, Nadezda Prvulovic, Gaspar Enríquez, Anna Jaquez, Roger Winter, Gloria Osuna Pérez, James Drake, Harry Geffert, Sam Reveles, Charles Mary Kubricht, Earl Staley, Jesús Bautista Moroles, Gael Stack, Vernon Fisher, Celia Alvarez Muñoz, Vincent Burke, Margarita Cabrera, and Derek Boshier, to name just some of the 165 Texas artists in the Museum's holdings.

Two exhibition programs and one membership program inaugurated in 1991 continue to help concentrate the collections. "Artists on Art," a program that show-cases art by local, emerging El Paso artists, involves displaying one work of art for a month. As part of the program, the artist provides a gallery talk about the work on display that connects to the Museum's permanent collection. The second program, "Focus," is an exhibition series showcasing artists who are known throughout the region. The exhibition components are: 15 to 20 works displayed, the understanding that the Museum will purchase one work from the show, and the publication of an illustrated brochure, which is distributed nationally. Through these two exhibition programs, the Museum has showcased hundreds of local and regional artists. The

Museum's membership program, "Members' Choice," has also contributed to the growth of Texas art in the collection. Each year, the members' holiday party revolves around the selection of one object chosen from three works curated by staff but voted on by the membership and purchased through membership funds. Through "Members' Choice" artists like: Carlotta Corpron, Ed Blackburn, John Biggers, Frances Bagley, John Alexander, Mary McCleary, and Gael Stack have entered the collection, which now numbers over 700 works by Texas artists.

The Museum's high regard for artists is based on the simple notion that without them life would be darker and there would be no need for art museums. Relationships built with artists over the years have resulted in significant gifts to the Texas collection as well. A number of artists have gifted the Museum with their works, like a monumental James Surls sculpture donated by his good friend, the artist John Alexander. James Surls and Charmaine Locke presented the Museum with more than 12 works by Texas artists they had collected during their Splendora years, and because of their generosity, artists Mark Monroe, Joe Havel, Chuck Dugan, Bill Haveron, Ken Luce, and Jeff DeLude entered the collection in 2000. In 2003 an innovative collaboration between the Museum of Fine Arts, Houston and Dallas-based Texas art collectors, Nona and Richard Barrett, ensured that 14 works entered El Paso's collection. This important gift filled gaps of artists missing from the Museum's collection like: Sydney Yeager, Patricia Forrest, Steve Brudniak, Barbara Simcoe, Tom Orr, and James Woodson, and it expanded the Museum's holdings with additional works by artists Mark Monroe, Bill Haveron, Earl Staley, and Dan Rizzie. Additionally, artists Luis Jiménez, James Surls, and James Drake suggested over the years that their collectors consider the Museum when thinking of donating works to an art institution, and we are grateful to the many collectors who followed their advice.

It is not only contemporary Texas artists who are entering the collection. The Museum has received through gift and purchase works of the 19th century itinerant cityscape painter, Léon Trousset and early 20th century artists Frank Reaugh, Grace Spaulding John, Olin Travis, Julian Onderdonk, Otis Dozier, Fern Thurston and her son Eugene Thurston, Mary Doyle, Blanche McVeigh, Alexandre Hogue, John Biggers, and Jerry Bywaters to name only a few. These works join other Texas artists in the

collection that include Robert Onderdonk, Audley Dean Nicols, Woody Crumbo, Hari Kidd, Manuel Acosta, José Cisneros, Charles Umlauf, and Urbici Soler.

In 1995, a statewide campaign was launched to name and endow a Tom Lea Gallery within the new art museum building that was then under design. Tom Lea was born, raised, and lived his life in El Paso (1907-2001). He had studied in the late 1920s at the School of the Art Institute in Chicago. He was a muralist, painter, illustrator, war correspondent for Life Magazine, and in the 1950s, a bestselling author who saw two of his books, *The Brave Bulls* and *The Wonderful Country*, made into movies. Tom Lea's character was carved from this unique area of Texas and it is this region that served as his muse in his myriad of accomplishments. The gallery campaign was a success, and when the new building was inaugurated in 1998, the much loved and well-respected Tom Lea's name was on the gallery walls along with numerous works of his art, which now number over 80 in the collection. Tom Lea captured this specific place both in words and images. His art continues to serve as a psalm to Texas, a place of history and heroes that so inspired him throughout his long and well-lived life.

The El Paso Museum of Art is expanded through the focus on the art and artists of the region. Visitors understand better this particular place in the Southwest by viewing the art on display. They see the early vistas recorded by 19th and early 20th century artists and can compare those views with contemporary interpretations of the land and its people. Viewers better know who we are, where we have been, and envision where we hope to go through the eyes of the state's artists. Expanded as well is the research potential for now and future scholars of the art of Texas and the region. The Museum's commitment to tell the story of Texas art through its history is realized in these holdings.

Becky Duval Reese
Director 1991-2005

TEXAS 100 Selections from the El Paso Museum of Art

MANUEL ACOSTA
1921-1989

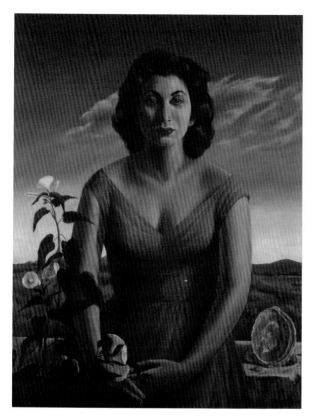

Manuel Acosta's imagery exemplifies the people and heritage of his region. His empathy for his friends, family and culture is depicted throughout the portraits and illustrations he created. Born in 1921 in Villa Aldama, Chihuahua, Mexico, Manuel Acosta's family moved to El Paso when he was an infant. His experience with art growing up was limited—he drew pin-up girls in his high school art class.

Drafted in WWII and sent to Europe as an air glider mechanic, Acosta visited an art gallery there and saw his first oil painting: "That's where it hit me," and from then on his major interest was art. Acosta's muse changed from high school but always returned to those he knew best. In the portrait *Yolanda* a neighbor and friend sits for the artist flanked by symbols of fecundity. If this work and Tom Lea's 1939 portrait of *Sarah* were compared, the two paintings are strikingly parallel. Manuel Acosta often spoke of his admiration for the work of Tom Lea, perhaps the Yolanda portrait, created some 17 years later demonstrates that esteem.

Manuel Acosta began painting seriously in 1947 taking training at Chouinard Institute in Los Angeles and studying with Urbici Soler at Texas Western College. He worked with Peter Hurd and his wife Henriette Wyeth on a fresco mural commission at the West Texas Museum. Manuel Acosta's work is in numerous public and private collections in the region.

ABP

Yolanda, 1956
Oil on panel, 42 x 32"
Gift of Yolanda Alvarado

JOHN ALEXANDER
born 1945

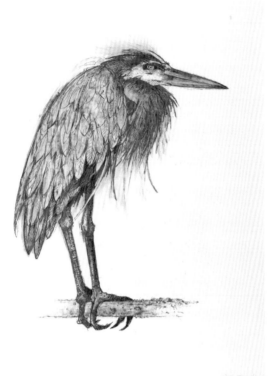

John Alexander rose to prominence in the 1980s with figural works that embrace the swampy, murky imagery and dry humor of East Texas. Alexander states that he likes his "paintings to be both funny and a bit frightening at the same time." His works employ a contemporary bestiary of bayou animals as well as society mavens, bishops, and officers that question socio-political hierarchies. Other Texas contemporaries who received national attention around the same time include James Surls, Dan Rizzie, Melissa Miller, Earl Staley, and James Drake, all represented in the Museum's collection.

Critics have compared Alexander's animal imagery, particularly birds, to John James Audubon and J.M.W. Turner. Alexander balances extremely life-like details with anthropomorphic characteristics enabling him to project emotion onto subjects such as *Angry Heron*. Peering back, with one eye firmly on the viewer, the heron is poised to strike anyone who dares to come too close. A symbol charged with meaning in almost every culture, the heron represented vigilance to the ancient Greeks, serenity and contemplation to the Chinese, and war and death to the Celts.

Born in Beaumont, Texas, John Alexander received his BFA in 1968 from Lamar University in Beaumont and his MFA in 1970 from Southern Methodist University. After graduate school he accepted a faculty position at the University of Houston. In the late 1970s he left for New York City, settling first in Soho and later leaving the city for Amagansett, New York, where he now lives.

ABP

Angry Heron, 2001
Color lithograph, 30 x 22"
Members' Choice Purchase

DAVID AYLSWORTH
born 1966

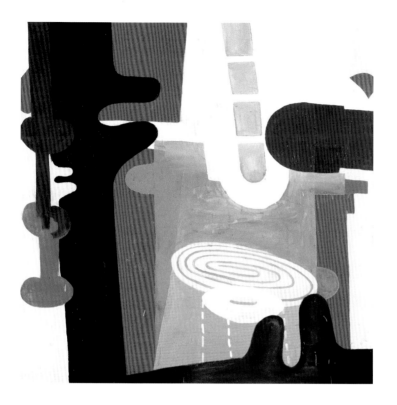

Like many artists working today, David Aylsworth draws inspiration from both the canon of art history and the popular culture that defined the 20th century. He invites inevitable musical analogies to his abstract paintings by culling the lyrics of icons such as Cole Porter, Lorenz Hart, Jule Styne, and Stephen Sondheim for many of his titles. Aylsworth's visual language with its buoyant color, linear rhythms, and biomorphic geometries tickles the eyes, but it is the tactile quality of these works that ultimately creates the most presence. Built up of layers of paint, dripped, scraped, removed, painted over, Aylsworth's surfaces record tangible gestures and form a rough counterpoint to the polished melodies and slick entendres of his often lyrical inspirations. *Oral Fixation* is a prime example of Aylsworth's approach in the mid-1990s, a period when the artist embraced the monumental, deftly-fused, and increasingly complex compositions together in large-scale formats.

David Aylsworth studied at Kent State University in Ohio and has been an Artist in Residence for the Core Program at the Glassell School of Art at the Museum of Fine Arts, Houston. He currently lives and works in Houston.

BF

Oral Fixation, 1997
Oil on canvas, 72 x 72"
Gift of the artist in honor of Alton and Emily Steiner

FRANCES BAGLEY
born 1946

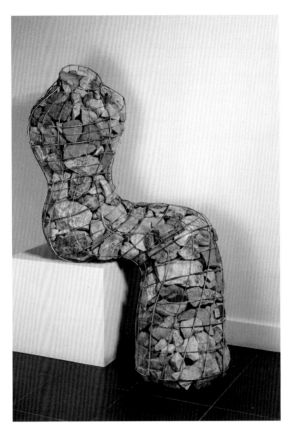

The female figure, a subject traditionally relegated to the realm of the academic and patriarchal, has been radically reassessed by a number of contemporary artists and critics as a potent vehicle to examine issues of identity and culture. Frances Bagley's sculptures, in a variety of media, have consistently used the female figure as a point of departure to explore personal subjectivity. "My abstract figures attempt to speak of the human spirit as an icon of human experience, although frozen outside of time." Driving her work are the endless contradictions it embodies: presence and emptiness, serenity and energy, strength and fragility, the primordial and the present.

Taking inspiration from ancient antecedents, Bagley's massive "woven" abstracted figures evoke the weighty pediment figures of the Parthenon while consciously stressing the body as a vessel, exhibiting open and sometimes filled interior space. *The Portrait* further alludes to classical sculpture with broken, unpolished marble filling the steel armature. These pieces of stone take on emotional resonance as well. Bagley clarifies, "my use of broken stone implies how I feel about the way we women often build our characters and our lives by the adding up of many experiences (some large and some small)." Encountering *The Portrait* with its cleverly open title, viewers can project their own identity onto the work and are challenged to define and evaluate the individual experiences that have contributed to their own sense of self.

Frances Bagley studied at Arizona State University, and the University of North Texas. She lives and works in Dallas.

BF

The Portrait, 1997
Stainless steel and marble, 72 x 48 x 36"
Members' Choice Purchase

DAVID BATES
born 1952

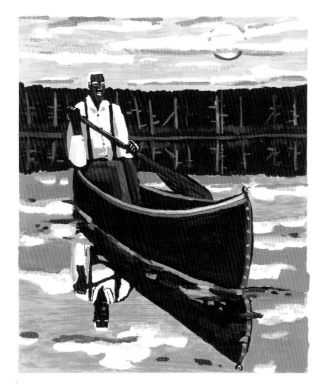

The identity and story behind the man paddling the canoe in *Full Moon* is unknown, but the image intentionally evokes many narratives. Uncomplicated, yet psychologically stimulating, *Full Moon* is a characteristic example of David Bates' work, which incorporates the themes of man and nature.

In terms of formalism, Bates' work is as much inspired by folk art as by the 20th century masters Pablo Picasso, Max Beckman, and Marsden Hartley. Bates usually paints from memory, and his technique is characterized by the use of thick black outlines and bold colors applied in large, semi-abstract brushstrokes. In the 1980s, Bates became known as a painter of still-life and figures as well as landscapes set in swamps and bayous along the Texas Gulf Coast. Since the mid 1990s he has maintained interest in similar subjects, while making an aggressive shift in media to low-relief paintings and sculpture. The "real people" depicted in his genre scene images with their open-ended narratives deliver the charm that made him famous.

Bates received his BFA and MFA from Southern Methodist University. In 1977 Bates participated in the Whitney Independent Study Program in New York City. He was also an exhibiting artist in the 1987 Whitney Biennial. His prints, paintings and sculptures are found in private and public collections around the country, including the following selected public collections: the Corcoran Gallery of Art, Washington, D.C.; the Dallas Museum of Art; the Metropolitan Museum of Art, New York City; the National Museum of American Art, Washington, D.C.; the San Francisco Museum of Modern Art; and the Whitney Museum of American Art, New York City.

CJG

Full Moon, 1992
Mixed media and woodcut on paper, 45 1/4 x 38 1/4"
Purchase in memory of Kayla and Ron Marks

BRUCE BERMAN
born 1944

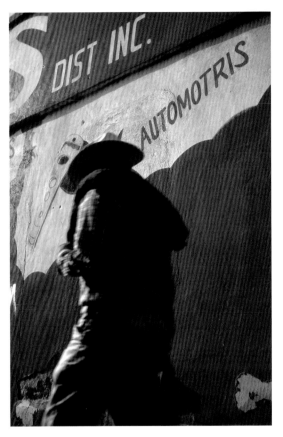

For the past 30 years, Bruce Berman has been taking some of the most captivating photographs of life on the Border. In the vivid color photograph *Day Laborer Returning to Mexico*, Berman captures a daily ritual on the El Paso-Juárez border. The subject is a man in a blue flannel shirt and khaki pants walking in front of a vibrant red concrete wall with the word "*automotris*" scrolled across it. He appears to be carrying a small tool bag and is also wearing an oversized hat to protect his face from the sun. On the Border, this sight is very common, as he is an "everyman," a laborer who is crossing back into Mexico after a hard day's work in the United States.

In retrospect, Berman would have called this photograph *Weight* instead of *Day Laborer Returning to Mexico*, because it represents a laborer from Mexico who, since he is not a skilled worker, is willing to work at a lower rate of pay than most Americans are willing to accept. "To me, this image is about the *weight* of coming over to the U.S., doing really, really hard work, then carrying yourself home to Mexico for a little sleep with a little money in your pocket, just to repeat the process the next day, except, there is no certainty that that work will be there the next day without a whole lot of scrambling to get it," says Berman.

Berman studied at the University of Oklahoma School of Journalism and the Art Institute of Chicago and has been a professional photographer since 1968. His photographs have been featured in *Texas Monthly*, *The New York Times*, *Time Magazine*, *Vanity Fair*, *Newsweek*, and *Dwell*, among others.

KM

Day Laborer Returning to Mexico, 1985
Cibachrome print, 11 x 14"
Purchase with funds provided by the Robert U. and Mabel O. Lipscomb Foundation Endowment

JOHN BIGGERS
1924-2001

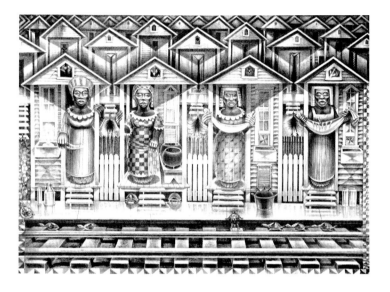

From the onset of his career, John Biggers offered people an opportunity to connect with their African-American and African cultures by creating works that set forth a proud and positive portrayal of those cultures. His subjects possess a deep connectivity to the earth and a profound respect for the day-to-day tasks necessary for survival. It is without doubt that his work has supplied a voice for black artists as well as African-Americans who have struggled for equality in America.

In 1941, John Biggers entered Hampton Institute (now Hampton University) and then Pennsylvania State University, following his artistic mentor and eventual friend Viktor Lowenfeld. Lowenfeld encouraged Biggers to draw from personal experience and research the art and culture of his African heritage. He developed paintings and murals that highlighted ordinary people engaging in everyday life activities. With a Master's in Art Education, John Biggers moved to Houston in 1949 to follow in the footsteps of his mentor and develop an art program at Texas State University for Negroes (now Texas Southern University), which he oversaw for thirty-four years. In 1957 he took his first trip to Africa under a UNESCO fellowship that provided a first-hand look at the people and lifestyle he had studied from afar. This trip affected Biggers' work profoundly, and subsequent trips to Africa would continue to fuel his appreciation and creativity.

Four Seasons captures the majestic and reverent style that is signature of John Biggers. The nurturing quality of African-American women is embodied in four matriarchs poised and ready to sustain the earth throughout the year. The rows of shotgun houses are reminiscent of housing along the South but also of abstract geometry and patterns found in African textiles. The uses of symbols, such as the turtle, are references to African mythology. These combined elements continue to provide audiences a picture of the African-American experience that embraces its African roots.

NM

Four Seasons, 1990
Lithograph, 22 ½ x 31"
Members' Choice Purchase

ED BLACKBURN
born 1940

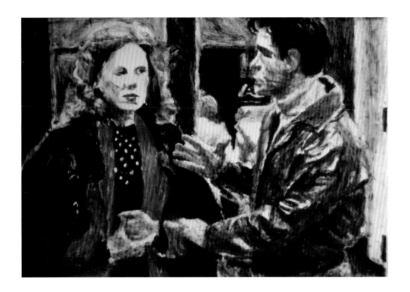

Ed Blackburn came of age when abstract expressionism dominated teaching at university art departments. Nationally, pop art was also gaining attention. Blackburn's response to this Zeitgeist saw him incorporate the techniques of abstract expressionism, pop art, realism, and trompe l'oeil in order to depict the pervasive bombardment of our sensibilities by media images or gossip column photographs. In the late 1970s, Blackburn added furniture, wallpapered panels, lamps, and light switches to his two-dimensional un-stretched canvases of recognizable media personalities, which further obfuscated the literal surface meaning of his works.

Like many artists today, Ed Blackburn knows the history of art. Fencing with subtleties of style, form and content gives him pleasure, and the play of seemingly irreconcilable form and content reflects his delight in manipulating art historical concepts. Blackburn works in an almost totally abstract expressionist style, weaving drips and splatters within his compositions. Interestingly, the artist's abstract forms often articulate subjects that appear realistic but come straight from Hollywood. In Untitled, Blackburn utilizes a still from the 1978 campy movie thriller "The Eyes of Laura Mars," depicting a scene between stars Faye Dunaway and Tommy Lee Jones. Blackburn's art elicits a sense of mystery, familiarity, and déjà vu as he exploits movie images ingrained in us by offering multi-layered narratives. Overlapping allusions established through the style, form, and content of his work are Blackburn's major concern.

Ed Blackburn studied at The University of Texas at Austin, the Brooklyn Museum and the University of California, Berkeley. He lives in Fort Worth, Texas.

BDR

Untitled, 1986
Color monoprint, 22 1/2 x 30"
Members' Choice Purchase

GAY BLOCK
born 1942

Gay Block's interest in photography dates to her pre-adolescence picture-taking of friends and family using her Brownie box camera. By the 1970s her professional scope expanded to include members of her affluent Jewish community in Houston. Block soon went far beyond her immediate surroundings and began a long-term collaboration with author Rabbi Malka Drucker. Together they traveled to eleven countries interviewing and photographing over 100 Christians who had helped save Jews during the Holocaust. The resulting body of work; *Rescuers: Portraits of Moral Courage in the Holocaust* was exhibited at the Museum of Modern Art in 1992 and has since traveled widely.

One portrait from this series, *Irene Gut Opdyke, Poland/California*, presents a confident blonde-haired woman gazing directly at the camera. During World War II, Irene Gut Opdyke overheard German officers planning to exterminate an entire ghetto. When she was subsequently given orders to serve as housekeeper to one of the officers she knew that she had means and opportunity to save many lives. Gay Block's rescuer portraits help us understand that humane acts dwell within us.

Gay Block studied at Newcomb College of Tulane University, the University of Houston School of Architecture, and studied with Geoff Winningham and Garry Winogrand. Her work has been published in books and in films, and is in both private and public collections including the Museum of Modern Art, New York City; the Museum of Fine Arts, Houston; the Amon Carter Museum, Fort Worth; the Jewish Museum, New York City; the Santa Barbara Museum of Art; and the San Francisco Museum of Modern Art.

AG

Irene Gut Opdyke, Poland/California, from the series *Rescuers*, 1988
C-Print photograph, 24 x 20"
Purchase with funds provided by Holli and William R. Berry, Mimi R. Gladstein, and
Regina Reisel in honor of Henry Kellen

JIM BONES
born 1943

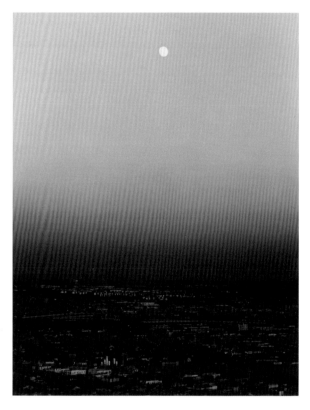

In *Moonrise Over McDonald's From El Paso's Scenic Drive* Jim Bones captures seemingly ordinary images that invite the viewer into the land-scape. The title refers to the anti-industrial 1941 photograph, Moonrise Over Hernandez, New Mexico by Ansel Adams. Bones continues that tradition by examining the popu-lated and developed terrain of the region. By including commercial symbols like the famous golden arches, he reflects the culture of consumerism. He creates an image that exalts the natural beauty of the moonrise within the urban landscape of the El Paso-Juárez region. Jim Bones typically works with a large format view camera and 4 x 5 film and in this work, he used the dye-transfer process.

While not simply portraying the lights in the evening sky, the artist merges the constellation of manmade lights with the starry moonlit night. As lights wrap around the mountains, the hard edges of the desert terrain are softened.

Jim Bones studied at the University of Texas at Austin. His work is widely published and is held in numerous private and public collections, including the Amon Carter Museum, Fort Worth. Jim Bones currently lives in Tesuque, New Mexico.

AG

Moonrise Over McDonald's From El Paso's Scenic Drive, 1980
Dye transfer print photograph, 16 x 20"
Gift of the artist

DEREK BOSHIER
born 1937

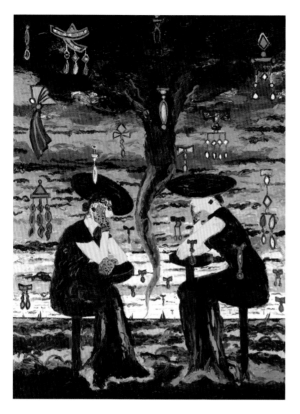

Derek Boshier gained international recognition within the1960s British pop art movement. His relocation to Houston in the 1980s added new images to his media-inspired repertoire. Known for his self-referential frightened cowboy series, nude male images festooned only with a 10 gallon Stetson, Boshier appropriated the major icon of western mythology, the cowpoke, which he placed in vulnerable locations throughout the Texas landscape. *Black Hats* abandons the nude cowboy horse opera for an interior/exterior allegory. In this episode, two elegantly dressed women in black sit face to face on bar stools that are perched upon roiling waters. The two figures remain calm, while a threatening waterspout rains earrings from the sky. The imminent conflict and turbulence of the narrative is underscored by Boshier's use of thick paint surfaces: a dark palette of blacks and grays is contrasted by the pink of the women's arms and faces. Staging the interior action outdoors, the artist challenges the natural order as he sets us to wonder.

Born in Portsmouth, England, Derek Boshier studied at the Yeovil School of Art in Somerset and at the Royal College of Art in London. From 1980 to 1992 he taught at the University of Houston and then returned to England. In 1997 the artist came back to the U.S. and joined the faculty of the California Institute of the Arts in Los Angeles.

BDR

Black Hats, 1987
Oil on canvas, 84 ½ x 60"
Gift of Jeff Sagansky and Christy Welker

JULIE BOZZI
born 1943

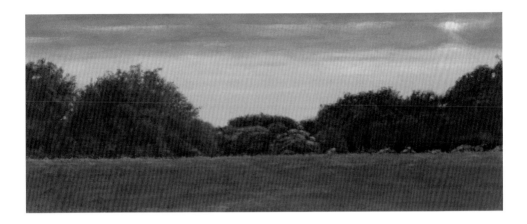

Landscape painting maintains a long and important tradition in American art. Artists continue to sketch and paint outdoors, but today technology is impacting methodology. For Julie Bozzi her automobile is the vessel for inspiration. She finds her muse driving on interstate highways, dusty country roads, and city streets. Using her car as a studio, Bozzi positions herself in abandoned parking lots or on the shoulders of roads and gets to work. The steering wheel serves as her easel, predetermining the intimate scale of her art. Bozzi uses a variety of media that include oil, watercolor, and gouache on surfaces such as paper, canvas, linen, and panel.

In *Trees Beyond a Grassy Slope*, the direct frontal, horizontal representation of the view departs from the more traditional compositional elements associated with landscape painting. Bozzi paints with precision using detailed studies of elements important to the finished work. Departing from the tradition of the picturesque, which relies on an artificially created focal point, Bozzi quietly explores the edges of the land. Her vision of the landscape is not a romanticized postcard for tourists, but rather relies on stripping away the pretense of predictability.

Bozzi completed her MFA at the University of California at Davis and also studied at Skowhegan School of Painting and Sculpture in Maine. Bozzi's work is in public and private collections, including the Brooklyn Museum; the Hirshhorn Museum and Sculpture Garden, Washington D.C.; the Dallas Museum of Art; the Modern Art Museum of Fort Worth; the Museum of Contemporary Art, San Diego; and the Museum of Fine Arts, Houston. Julie Bozzi currently lives and works in Fort Worth.

AG

Trees Beyond a Grassy Slope, 2001
Oil on panel, 4 x 10"
Purchase with funds provided by the Robert U. and Mabel O. Lipscomb Foundation Endowment

STEVE BRUDNIAK
born 1961

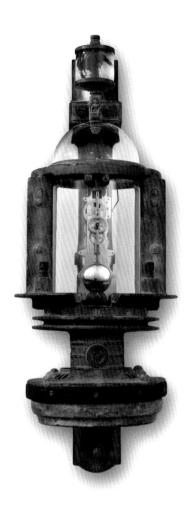

Steve Brudniak navigates the coalescence of art and science in his assemblages. Although the image of the mad scientist is often invoked when discussing his work, Brudniak's process and concerns are more closely attuned to the magic of alchemy. Culled from defunct machinery, ephemera, human blood, and animal remains, his sculptures function as mystical fetishes invested with spiritual power over collective fears and neuroses. *Healer/ Destroyer*, like other works from the last decade are imbued with the passage of time with heavily worked patinas, rust, and corrosion, allowing the work to act as historical artifact instead of art object.

The work comprises an old barber's pole, an antique tractor drip oiler, and a scorpion floating in antifreeze. Brudniak maintains that *Healer/Destroyer* is a machine and ritual device operating "as a paradigm for psychological function and dysfunction." He says, "I like to make machines that symbolically act as a shaman might use—a rattle or wand or something to take away problems or sins." Largely self-taught, Steve Brudniak lives and works in Austin.

BF

Healer/Destroyer, 1994
Mixed media, 28 x 10 x 12"
The Barrett Collection, Gift of the Museum of Fine Arts, Houston

VINCENT BURKE
born 1965

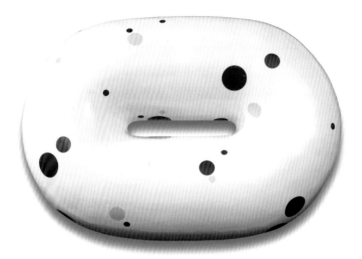

In *Guero (Oompa)*, Vincent Burke conveys humor as he is inspired by the culture of El Paso. Burke explores his ideas through a series of simple oval forms. While his is a serious intellectual investigation, he pokes fun at what he has called the "doughnut shape" of many of his sculptures.

In this work, Burke addresses the interpretation of the word *guero*, slang in the El Paso-Juárez border region for "whitey" or "cracker." Burke connects ideas about culture, language and identity by interpreting the packaging design for what is perhaps the whitest of all breads, *Wonderbread*, a name that has been appropriated as a critical description of white identity.

Vincent Burke's work proposes a new frame of reference and challenges the viewer to analyze the meaning of his work. Restriction and repetition of the wall-mounted elliptical forms are the foundation of a stylistic and conceptual pluralism. Through his ability to combine familiar designs in a unique way, Burke's ceramic sculptures are open to interpretation and typically raise more questions than they answer.

Burke's sculpture has been exhibited in cities across the United States. He studied at Louisiana State University and Carleton College in Minnesota. He is on the faculty of the University of Texas at El Paso.

AG

Guero (Oompa), 2000
Ceramic, 14 1/2 x 21 x 6"
Purchase with funds provided by the Marian Meaker Apteckar Foundation

JERRY BYWATERS
1906-1989

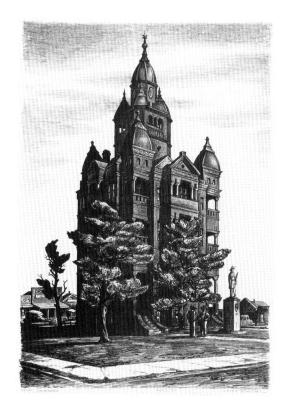

Embracing the style of regionalism, Williamson Gerald (Jerry) Bywaters and the many artists within his galaxy sought to elevate the commonplace in order to seek universal truths of the human condition. In 1983, the exhibition *Texas Images and Visions* re-introduced the state's regionalist artists to a new and appreciative audience, which resulted in a flurry of new exhibitions of their work. The 1985 exhibition *Lone Star Regionalism: The Dallas Nine and Their Circle, 1928-1945* introduced the phrase "the Dallas Nine," which is now used to describe and define the circle around Bywaters that included: Alexandre Hogue, Otis Dozier, William Lester, Everett Spruce, Thomas Stell, Harry Carnohan, John Douglass, and Perry Nichols.

In 1938, Bywaters and his artist-friends formed the Lone Star Printmakers, whose purpose was to "encourage printmaking and to circulate and sell [their] prints throughout the region." His interest in architecture was realized in a series of prints that began with the reality of Texas courthouse buildings, and in the words of the artist, "'adjusted' them for character." In *Texas Courthouse*, artistic license trumps reality, and Jerry Bywaters, who was well known for his humorous interpretations of events, offers the viewer a glimpse of the law west of the Pecos River as seen through a gothic sensibility.

Jerry Bywaters was born in Paris, Texas. He studied comparative literature at Southern Methodist University and after graduating in 1927 spent the following two years traveling in France, Spain, Mexico, and the eastern United States. He enrolled in classes at the Art Students League in New York City and returned to Dallas in 1929 a more informed and experienced artist. In 1943 he was named director of the Dallas Museum of Fine Arts and for the next 21 years served as an active force for Texas art.

BDR

Texas Courthouse, circa 1956
Lithograph, 26 ½ x 20"
Gift of Nancy Stewart in memory of Charles A. Stewart

MARGARITA CABRERA
born 1973

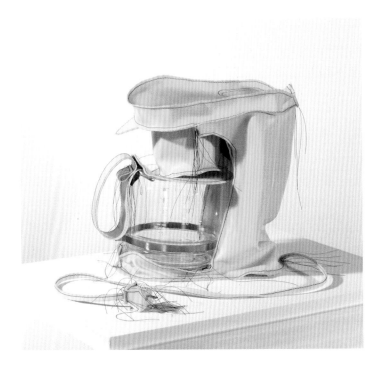

Margarita Cabrera's use of bold pop colors and grid compositions share the visual language of Andy Warhol and Jasper Johns. While she continues the visual aesthetic of other Pop artists like Claes Oldenburg, the personal, cultural and political content in her work sets Cabrera apart. Her work addresses issues related to the *maquiladora* industry, which is the name given to American assembly plants in Mexico.

Cabrera began visiting Mexican factories where she observed conflicting dynamics; some had a festive atmosphere while others seemed harsh and dangerous. Employees on the assembly lines work long hours for low wages and often cannot afford to purchase the products they manufacture.

In her soft sculptures Cabrera offers a metaphor for the lack of support for the workers. She begins each piece by taking away all material used by the laborers and replacing it with colorful vinyl fabric. She sews the vinyl pieces together with stitching that leaves the threads exposed emphasizing hand labor. Despite the fact that Cabrera is addressing serious labor and consumer issues, she does not deny the unique tactile quality of her work or the visually playful aspects of the sculpture.

Originally from Monterrey, Mexico, Margarita Cabrera came to the United States as an adolescent and continues to explore her cultural heritage through her art. She lives and works in El Paso.

AG

Coffee Maker M.I.M., 2001
Vinyl, metal, glass and thread, 10 ³/₄ x 13 x 17"
Purchase with funds provided by the Robert U. and Mabel O. Lipscomb Foundation Endowment

CARLOS CALLEJO
born 1951

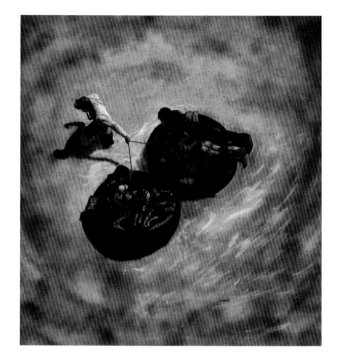

Having lived in both Los Angeles and El Paso during the late 1960s, Carlos Callejo developed an ardent interest in border issues and community needs. Callejo sought to demonstrate the plight of Mexican-Americans, and he turned to the vibrant, larger-than-life world of public murals that have informed the style and content of his art. He has produced numerous public commissions, which coupled with training in fresco painting in Italy, expanded his *oeuvre*. Keenly aware of mural traditions that incorporate social and cultural issues, Callejo successfully merges his technical abilities with his message. As a master muralist, Callejo is aware of the power of visual perspective, which he utilizes in his pastel, *La Cruzada* (The Crossing). Using a bird's-eye perspective we see the drama of humans struggling to cross the muddy waters of the Rio Grande, which was once a way of crossing the river to secure employment.

As in his murals, Callejo takes a complex social/political situation and concentrates the concept into a condensed visual message. With this perspective he conveys the vulnerability of the people as they tenuously cross the Rio Grande. In *La Cruzada*, Callejo successfully demonstrates the human struggle for the possibility of a better life.

Born in El Paso, Callejo lived in Los Angeles for more than 30 years before moving back to Texas in 1986. He studied at the Otis Art Institute and at California State University, Los Angeles. He was awarded the Lila Wallace—Reader's Digest Fund—Arts International grant that provided him with funds for a residency in Spoleto, Italy to study the work of 14th and 15th century fresco masters. This internationally known artist has completed numerous public art commissions and his work is both publicly and privately collected. Callejo currently lives and works in Canutillo, Texas.

AG

La Cruzada, 1991
Pastel and prismacolor on paper, 54 ³/₄ x 51"
Purchase with funds provided by the Robert U. and Mabel O. Lipscomb Foundation Endowment

MANUEL CARRILLO
1906-1989

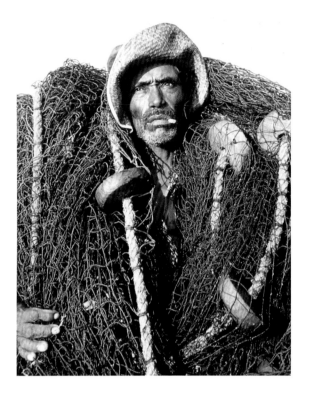

During the thirty years that Manuel Carrillo lived in Mexico City, where he was born, he was inspired by the ways tourists portrayed the Mexican people in photographs. He adopted photography as a hobby at the age of 49, learning his photographic techniques through the Photographic Club of Mexico in Mexico City.

Today Carrillo is best known for his sympathetic photographs of the people of Mexico. His photographs are not about glamour, but rather about the human qualities and day-to-day experiences of working people, as portrayed in *Fisherman Wrapped in Net, Cigarette in Mouth*. For this reason he titled his largest series of photographs *Mi Pueblo*, hoping to allow the viewer to understand the "true face" of the mid-20th century Mexican from a Mexican's point of view. Carrillo's second major series is titled *The Inseparables* and consists of photographs of people and animals, two groups of living beings Carrillo saw as interdependent. Carrillo's work has much in common with the most famous Mexican photographer, Manuel Alvarez-Bravo, because both photographed people of the lower economic strata and both were uninterested in the middle and upper classes.

Although Carrillo was born in Mexico City, the Photographic Society of America gave him the status of honorary citizen of El Paso in 1980 after a lifetime of travel between the U.S. and Mexico. Carrillo's first solo exhibition was in 1960 at the Chicago Public Library and traveled to forty different U.S. cities. Since then, his work has been seen in over three hundred exhibitions spanning over twenty countries. The El Paso Museum of Art has more than 250 photographs from Carrillo's two largest series. His work is also in the collections of the Museum of Modern Art, New York City; the Art Institute of Chicago; and the Victoria and Albert Museum of London.

CJG

Fisherman Wrapped in Net, Cigarette in Mouth, after 1950
Gelatin silver print, 13 ³/₈ x 10"
Gift of the artist

KEITH CARTER
born 1948

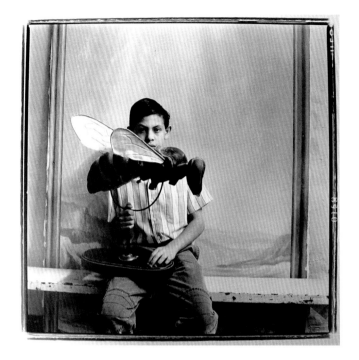

The presence of an unnaturally large bee next to a small boy may be somewhat startling, but with more careful attention the viewer soon realizes that the small boy is posing with the bee as a prop. This introduces us to Carter's unique ability to put his sitters at ease and allow special things to happen. Carter is comfortable behind the camera because he has been around photography since his mother, who was a professional portrait photographer, introduced him to it as a child. In addition to *Boy with Bee*, the El Paso Museum of Art also holds the photogravure *Luna*, a soft-focus moonlight image of a howling dog.

Originally born in Madison, Wisconsin, Carter has lived and worked in Beaumont, Texas his entire life, and he considers himself an East Texas photographer. His early work concentrated on suggesting a "sense of place and spirit" in his native southeast Texas. His "selective" focus photographs of ordinary subjects, such as children and animals, are often mysterious, magical, and dreamlike and have earned him the title "Poet of the Ordinary" by *The Los Angeles Times*.

Carter is mostly self-taught in photography and began teaching photography at Lamar University in Beaumont in 1988. That same year he earned Lamar University's University Professor Award. Numerous books featuring Carter's photographs have been published for over thirty years. Twice the recipient of National Endowment for the Arts Regional Survey Grants, Carter has exhibited widely in the United States, Europe, and Latin America. His photographs are found in prominent collections around the country such as the Museum of Fine Arts, Houston, the Art Institute of Chicago, and The Getty Museum in Santa Monica.

CJG

Boy with Bee, 1990
Toned gelatin silver print, 15 x 15"
Purchase with funds provided by I.T. Schwartz Family in memory of Tom Lea

MEL CHIN
born 1951

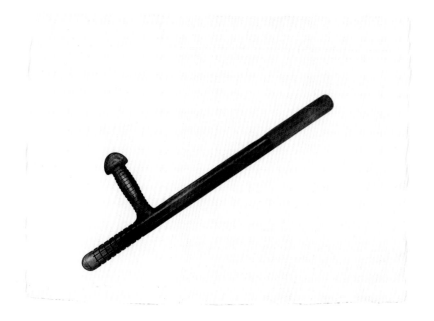

Although Mel Chin's work eludes quick categorization, it is poetic and often politically, socially, and ecologically engaged. Throughout his oeuvre, Chin has consistently challenged the idea of the artist as the sole force behind the creation of artwork, collaborating frequently with individuals from a variety of disciplines. Utilizing sites as diverse as toxic landfills, videogames, and even the campy 1990s television drama "Melrose Place," Chin subverts the formal museum/gallery setting that even the most progressive audience correlates to the act of viewing art. His art urges viewers to question the information they receive and the methods they use to process it.

Combo Club depicts Chin's ominous sculpture *Night Rap*, a police nightstick retrofitted with a wireless microphone for performances. Such a hybrid literally amplifies the voice of authoritarian power, while maintaining the mobility necessary for physical control. In the early 1990s, the use of a simple, bold, and accessible symbol of brutality resonated after heavy media coverage of the protests in Tiananmen Square, the Rodney King beating, and the subsequent rioting in Los Angeles.

Mel Chin studied at Peabody College in Nashville and has been the recipient of two fellowships from the National Endowment for the Arts. Born in Houston, he lives and works in Burnsville, North Carolina.

BF

Combo Club, 1993
Lithograph , 22 ³/₄ x 30 ³/₄"
Purchase with funds provided by the Robert U. and Mabel O. Lipscomb Foundation Endowment

JOSÉ CISNEROS
born 1910

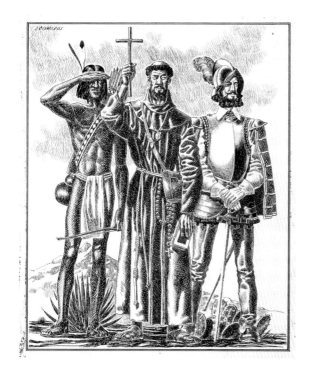

José Cisneros' oeuvre consists of thousands of illustrations depicting the Spanish heritage of Mexico and the American Southwest. When approached by *Southwestern Art* concerning an article about his work Cisneros enlisted his friend John O. West as the writer. Cisneros dictated to West the first line, "Although José Cisneros has gained considerable recognition as illustrator of books related to the history of the Southwest, past and present, his aim and intense desire has been to reconstruct and depict to the best of his ability the pageantry… of Mexico and the south-western border states of the U.S."

This untitled image depicts Spanish explorers and the Franciscan missionaries who first arrived in Paso del Norte in 1578. The work also includes a representative of the Mansos Indians who crossed the Rio Grande to explore what would eventually become the kingdom and province of New Mexico. Cisneros' romanticized imagery and theatrical style is self-proclaimed as 'Indian Baroque'.

José Cisneros grew up in Mexico during the Revolution, son of a poor family. Primarily self-taught, his family moved to Ciudad Juárez when he was young. He would cross the Rio Grande to El Paso to attend school. He moved permanently to El Paso in the 1930s where he currently resides. He has illustrated over 40 books, won numerous awards including an Arts and Humanities Medal, presented by President George W. Bush. Cisneros was knighted by King Juan Carlos of Spain for his contributions to the understanding of history through his art.

ABP

Untitled, 1945
Pen and ink on board, 12 3/4 x 9 3/4"
Gift of Dr. Nicholas Cummings and Margot Berlanga-Cummings

ALAIN GERARD CLEMENT
born 1946

Alain Clement is best known for the photographs he calls "photogenic drawings," made without using a camera. In the tradition of the early photographic pioneer William Henry Fox Talbot, Clement's process utilizes the oldest known technique of capturing the effect of light on a photosensitive material; however, Clement adds innovation to this process by placing his own drawings, instead of leaves or flowers, on the photographic paper to create images. The delicate, luminescent image of *Untitled #1* from Clement's *Garden* series of "photogenic drawings," provokes a sense of wonder and was inspired by a trip to North Africa.

The range of Clement's photographic work does not end with his "photogenic drawings," but the drawings mark the point to which he has currently arrived. In the late 1970s Clement's first successes were with straight color images of New York City. In the early 1980s he worked on a series of staged black and white photographs of constructed environments, some depicting flying grand pianos with mystical surreal undertones. Around the same time, Clement put his cameras aside and began exploring photograms of ever increasing scale and complexity.

In 1968 Alain Gerard Clement completed his Law degree at the University of Dijon, France, which he combined with the study of art history. Clement lived and worked in Paris until 1978; he then moved to New York City and subsequently to Houston. Clement's work has been the subject of exhibitions in museums and galleries throughout the United States and Europe since the early 1980s. His prints are in collections at the *Bibliothèque Nationale*, Paris; the *Musée Niècephore Niepce*, Chalons-sur-Saone; the Menil Collection, Houston; and the Dallas Museum of Fine Arts. In 1998 he was awarded a grant from the National Endowment for the Arts. Clement lives and works in Galveston.

CJG

Untitled #1, 2000
Silver gelatin photogenic drawing, 40 x 30"
Purchase with funds provided by the Robert U. and Mabel O. Lipscomb Foundation Endowment

CARLOTTA M. CORPRON
1901-1988

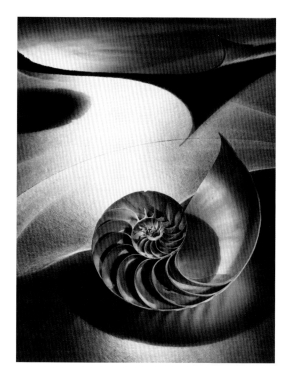

A committed artist and educator, Carlotta Corpron stands out among other Texas artists of the mid-twentieth century because of her avant-garde, modernist work with photography.

Born in Blue Earth, Minnesota, Corpron spent her childhood in India where her father was a missionary surgeon. She graduated in 1925 with a BS in Art Education from Michigan State Normal College (now Eastern Michigan University) and in 1926 with an MA in Art Education from Columbia University in New York City. After teaching in Alabama and Ohio and traveling in Europe and the Orient, in 1935 Corpron became a professor at Texas College for Women (now Texas Woman's University) in Denton, a position she held until 1968. Because she never owned a camera until she was thirty-two years old and in preparation for a photography class that she was scheduled to teach, Corpron studied creative photography one summer at the Art Center School in Los Angeles.

Corpron's work shows the influence of Lazlo Moholy-Nagy and Gyorgy Kepes, who were both on the faculty of the Institute of Design in Chicago and taught in Denton for one semester in the mid forties. *Chambered Nautilus* displays Corpron's primary interest: the expressive potential of light. In several of her series Corpron uses props such as seashells, mirrors, eggs, and Greek sculpture to capture the essence of light, producing work that is often more abstract than representational. Naomi Rosenblum, author of *The World History of Photography*, refers to Carlotta Corpron as one of the "others who started to regard photography as a way of working with light rather than solely as representing objects."

Corpron was modest and did not promote her work aggressively. In her lifetime her photography was the subject of several important group exhibitions as well as solo exhibitions at the Amon Carter Museum, Fort Worth; the Art Institute of Chicago; and the Dallas Museum of Fine Art.

CJG

Chambered Nautilus, 1950/1978
Gelatin silver print, 13 ³/₄ x 10 ³/₄"
Member's Choice Purchase

WOODROW (Woody) WILSON CRUMBO
1912-1989

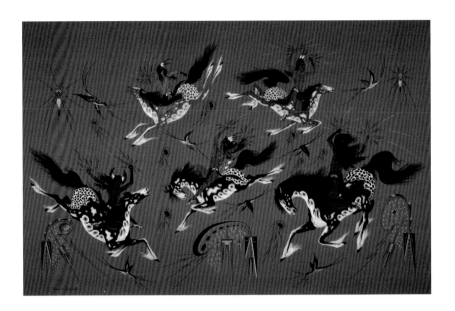

Potawatomi-born artist Woody Crumbo devoted his life to portraying and preserving American Indian traditions through his art, music, teaching, and advocacy. Crumbo was orphaned at seven and grew up with numerous Indian tribes and families in Oklahoma and Kansas, where he became interested in learning the unique songs and dances of each tribe. In the 1930s, Crumbo earned his living as an Indian dancer, and through his travels he widely disseminated both what he had learned and what he came to know, sparking in large part the contemporary Indian art movement. By the late 1930s, Crumbo was working in the visual arts. He garnered mural commissions for the Interior Department building in Washington D.C.; he worked as a freelance artist in Taos, New Mexico; and, in Tulsa, Oklahoma he was asked to form the American Indian art collection for the Gilcrease Museum of Art. Also in Tulsa, Crumbo completed murals for the Philbrook Museum of Art. By 1960, Woody Crumbo and his family (he had married a Creek Indian and together they had two children) were in El Paso working at the newly opened El Paso Museum of Art. By 1974, Crumbo and his wife returned to Oklahoma where he continued his artwork and his humanitarian activities on behalf of American Indians.

Thunder People, a quintessential Woody Crumbo painting, represents with charm, elegance, and sympathy the legends and spiritual beliefs of his ancestors. Woodrow Wilson Crumbo's works are in collections from Washington, D.C. to San Francisco. He participated in over1200 exhibitions in his lifetime and is rightly credited as one of the most important advocates for the contemporary Indian art movement of the 20th century.

BDR

Thunder People, 1969
Tempera on matboard, 31 x 44"
Gift of Mr. and Mrs. Paul Luckett

SUSAN DAVIDOFF
born 1953

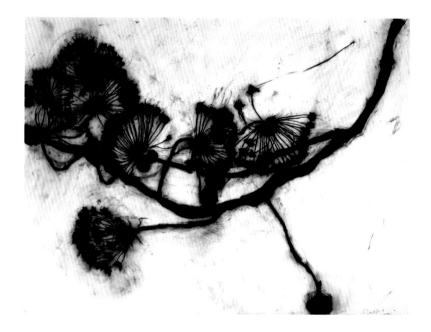

For Susan Davidoff her natural environment is a constant source of inspiration. In drawings and paintings she depicts indigenous plant life that often is mixed into her pigments. Davidoff's affinity with nature is coupled with an almost scientific precision, which allows her to elevate organic forms to high art. She balances technical precision and attention to detail with a fond and holistic interpretation of her surrounding landscape.

False Solomon's Seal No. 1 is a partial view of vegetation gathered on one of many hiking expeditions. According to Davidoff, both traveling and interacting with nature are activities that never fail to spark her creativity. Working confidently in charcoal, she abstracts the plant forms into their basic, essential shapes as she exaggerates their scale.

Susan Davidoff has studied in Austin, San Francisco, El Paso, and Las Cruces. She received her MFA from New Mexico State University. She has been the recipient of many awards including the Pollack-Siqueiros Binational Art Award facilitated through the Ford Foundation, as well as the Mid-America Arts Alliance Fellowship Award via the National Endowment for the Arts. Her work is found in many public and private collections including the Metropolitan Museum of Art in New York City.

AG

False Solomon's Seal No. 1, 1991
Charcoal on paper, 42 1/2 x 57"
Purchase with funds provided by the Robert U. and Mabel O. Lipscomb Foundation Endowment

SUSAN DAVIDOFF born 1953
RACHELLE THIEWES born 1952
BEVERLY PENN born 1955

Artistic collaboration is a complex undertaking that many artists might avoid. However, when three intelligent and talented artists came together to propose a project, they understood the unifying process of creating an art book, *Beauty.Chaos*. Critical in the success of this work and their collaboration was their mutual respect for their individual aesthetics within a harmonious work of art. In this project, Davidoff, Penn, and Thiewes explored their relationship with nature through different artistic mediums, converging their shared interest in the layered elements of nature and unifying the project through their deep respect for the earth and the High Chihuahuan desert of West Texas.

The cover, created by Penn, is etched with specific topographical details from their hikes and includes poetic inscriptions in three separate voices. Inside on the right, silk casing reveals sculptural forms created from precious metals and slate by Thiewes. These beautiful forms are intellectually challenging and compel the viewer to understand the marriage between nature and humanity. Lifting the page on the left reveals a series of drawings created from charcoal and other natural pigments taken from the desert by Davidoff. Avidly collecting

Beauty.Chaos, Book #8, 1999
Handmade book with precious metals, slate, charcoal and natural materials, 11 x 11 x 2" closed
Purchase with funds provided by the Robert U. and Mabel O. Lipscomb Foundation Endowment

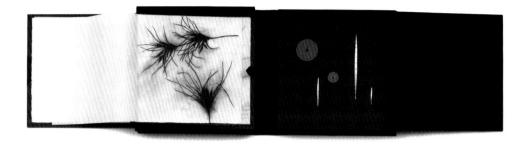

natural specimens, she creates a strong silhouette of plant material consequently increasing awareness of the abundance of these materials in nature.

Ultimately, collaboration with each other and with nature is the success of this work. As viewers we travel the layers of visual understanding. For the artists, the process was a journey, both literally and metaphorically as they explored the natural world and the dynamics of creating a work of art together. Davidoff studied at New Mexico State University and lives in El Paso. Penn also studied at New Mexico State University and currently lives in Austin. Thiewes studied at Kent State University and currently resides in El Paso. Collectively, all three are active artists and professors, receiving numerous awards and fellowships. Combined, their work is in a range of private and public collections worldwide, some of which include the Metropolitan Museum of Art, New York; the Austin Museum of Art; the Smithsonian's Renwick Gallery, Washington D.C.; the National Museums of Scotland; and the Art Institute of Chicago.

AG

MARY DOYLE
1904-1998

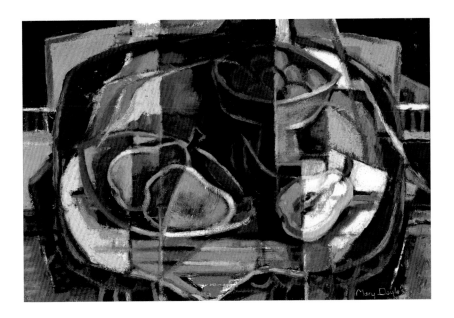

Mary Doyle sought knowledge throughout her long life. She received degrees from Southwest Texas State Teachers College (now Texas State University) in San Marcos and from Texas Woman's University in Denton—even as she attended, by her count, some twelve different universities throughout the course of her life. Doyle spent summers in various art colonies, the Dallas Museum of Art's school, or at Columbia University in New York City. For as long as she looked to learn, she passed on her knowledge through 37 years of teaching art for the Dallas Independent School District.

Doyle was an original member of the Texas Printmakers and was known widely for her serigraphs, a medium she taught herself. She was also an accomplished painter and in *Still Life with Pears*, Doyle's understanding of cubism is made apparent. Incorporating compositional elements like the tilted table top, fragmented surface, and skewed perspective, she was adept at interpreting Modernist forms of art and injecting her own originality. In this work, Doyle's monochromatic palette of gray and white is popped by her use of chartreuse, a color combination ubiquitous in the late 1950s.

Mary Doyle's mother was also an accomplished artist. No doubt inspired by what she saw growing up, Mary Doyle found her direction early and made it her lasting achievement.

BDR

Still Life with Pears, 1957
Oil on masonite, 12 x 18"
Purchase with funds provided by the Robert U. and Mabel O. Lipscomb Foundation Endowment

OTIS DOZIER
1904-1987

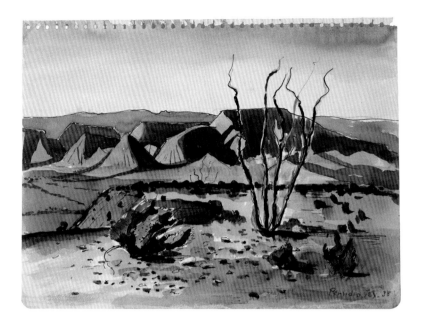

Citing the credo of regionalist artists, Otis Dozier once said, "You've got to start from where you are and hope to get to the universal." Born in Forney, Texas, Dozier studied with Vivian Aunspaugh at her Dallas art school and worked as a draftsman for his artist friend, Charles Bowling. Dozier subsequently taught at the Dallas School of Creative Arts, Southern Methodist University, and the Dallas Museum of Fine Arts. Throughout the Depression he completed murals in Giddings, Arlington, and Fredericksburg. A member of the Dallas School, Dozier and longtime friend Jerry Bywaters often traveled together, sketching the landscape of the Lone Star State.

Presidio, Texas, documents a trip to far West Texas made in the late 1930s. Torn from his sketchbook, the small watercolor records the dry desert with prickly pear and ocotillo plants in the foreground paired with mountains in the background. Brushed with brown and green watercolor, the study captures the feeling of isolation, emptiness, or for non-desert dwellers, an unknown land.

Dozier's long teaching career touched numerous artists of north Texas and his influence was widely felt. He was an advocate of artistic individualism and believed that a craftsman can copy nature but a good artist interprets what he sees.

BDR

Presidio, Texas, 1938 (misspelled by the artist: "Persidio, Texas")
Watercolor, ink and pencil on paper, 9 x 12"
Purchase with funds provided by the Robert U. and Mabel O. Lipscomb Foundation Endowment

JAMES DRAKE
born 1946

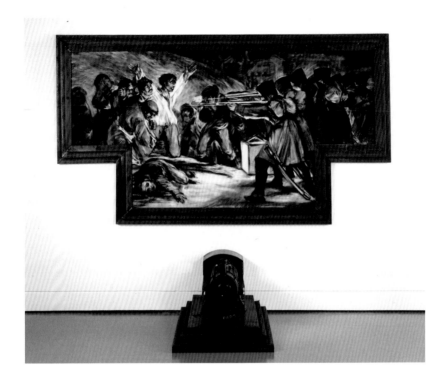

The protean art of James Drake resists easy categorization. A prolific sculptor, comfortable with site-specific installations, esteemed draftsman, and photographer who frequently collaborates with other artists, writers, and even mathematicians, Drake states his only stricture is "to do works that [he is] affected by or are close to [him]." In his thirty years in El Paso Drake has often explored the tenuous identity and turbulent politics of the Border.

When asked in an interview why he uses appropriated images, especially from Goya and Gericault, Drake replied: "because I like them and respond to them, that is the first reason. I am not an appropriationist. I'm really not. I put it in a new context of the parallel and more recent event of the deaths of the Mexican men in the railroad boxcar. That is why I did them all in black and white—thinking of newspapers and periodicals—because it changes the meaning considerably." *Cinco de Mayo* came out of the same event—the boxcar deaths. "I used an obviously policitical painting by Goya about killing people—and the locomotive sculpture beneath the drawing is meant to tie the two events together—but I don't think of my use of Goya's painting *The Third of May, 1808* as being similar to the way other artists appropriate images. It doesn't come from ideas that 'Art is Dead' and all of that kind of stuff. Art may be dead for them, it isn't for me."

Included in the 2000 Whitney Biennial was his series titled, *Que Linda La Brisa*, which

Cinco de Mayo, 1988-89
Steel and charcoal/paper, 84 x 112 x 36"
Purchase with funds provided by the Robert U. and Mabel O. Lipscomb Foundation Endowment

translates to "What a Lovely Breeze," a project which Drake developed through his association and support of the Mexican Federation of Private Health and Community Development Association (F.E.M.A.P.) in Ciudad Juárez, Mexico. F.E.M.A.P. provides aid to people in the "Zone" who work as prostitutes, are addicted to drugs, or have health problems.

Drake describes that, "Transvestites and transsexuals are the most abused and at risk group of sexual professionals along the border. It is the goal of F.E.M.A.P. to help protect them against disease and violence while promoting health awareness. Through this organization I was introduced to a group of transvestites and transsexuals who live and work turning tricks in the "zona marescal" a portion of Juárez devoted to drugs, prostitution and strip bars, even though this area can be highly intoxicating and dramatic, I wanted to photograph them in their homes, neighborhoods, with friends, and going about their daily lives. In all of my work I strive to focus on the humanity of people caught in a zone of desire, separation and alienation."

James Drake was born in Lubbock, Texas and lived in El Paso for more than thirty years. He received his BFA in 1969 and MFA in 1970 from the Art Center College of Design, Los Angeles, California. He currently lives and works in Santa Fe, New Mexico.

ABP

Que Linda La Brisa/ Lisa, Samantha, Tanya, 1999
Color Photography, 15 ³/₄" x 23 ¹/₂"
Purchase with funds provided by the Robert U. and Mabel O. Lipscomb Foundation Endowment

GASPAR ENRÍQUEZ
born 1942

Gaspar Enríquez's success in portraiture is as much about his technical virtuosity as it is about his deep empathy with the people he portrays. In the portrait ensemble *Generations of Attitudes*, four generations of Chicanos are depicted through their fashion. The work is a wall-mounted air-brushed low-relief sculpture. Enríquez uses his painting technique to create a style of photo-realism. The sense of realism combined with the scale of this work allows us to feel as if we are part of a tableau vivant.

The first group, *Los Pachucos*, refers to the men and women of the 1940s and mid-1950s, i.e. the Zoot-Suit era. The second pair, *Los Tirilones*, represent the men and women of the late 1950s and 1960s. The attitudes remained but the dress and style changed: army uniforms, khaki pants, wool shirts, and *tirantes* (Spanish for suspenders) were in style during this period. The third group, *Los Cholos*, presents a contemporary mix of street fashion from the LA skateboarding scene and graffiti artists. The three sets of "couples" and a man presented alone create a time narrative that allows the viewer to understand that while fashion changes, attitudes are handed down from one generation to the next. As captured by Enríquez, these individuals embody more than cultural pride—they also exemplify strength and vulnerability.

Enríquez is also known for his large-scale individual portraits like the powerful, *Luis y la Virgen de Guadalupe*. The muscular, solitary figure represents a self-assured man, but he also protects himself through his closed stance and mirrored sunglasses. Toughness is softened by

Generations of Attitudes, 1992
Acrylic on fiberglass foamboard, 72 x 264"
Purchase with funds provided by the Robert U. and Mabel O. Lipscomb Foundation Endowment

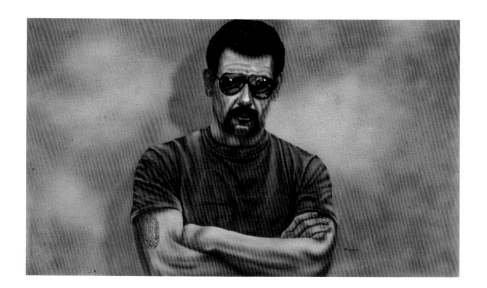

a subtle vulnerability. The title is another reminder that this man is not alone. To some degree, it is a double portrait of the man and the Virgin of Guadalupe tattooed on his arm. Contrasts between the masculine and feminine as well as the secular and non-secular are powerful dichotomies.

Despite the bravado apparent in Enríquez's portraits there is also an underlying layer of humanity and compassion. Enríquez is honest with respect to his roots and depicts his subjects with consideration, sympathy, and respect. Enríquez says he only portrays individuals with whom he connects on various levels.

Gaspar Enríquez was born and raised in El Paso. He received his training in Los Angeles, at the University of Texas at El Paso where he received a BA, and, at New Mexico State University where he received an MA. He taught art for many years at Bowie High School on the El Paso-Juárez border. His students have often been sources of inspiration. Enríquez has been included in numerous exhibitions including the nationally touring *Chicano Art: Resistance and Affirmation*. Gaspar Enríquez lives and works in San Elizario, Texas.

AG

Luis y la Virgen de Guadalupe, 1989
Acrylic on masonite, 36 x 55 $^{1}/_{2}$ x 4"
Gift of Martini DeGroat and the Southwest Bell Foundation

ADRIAN ESPARZA
born 1970

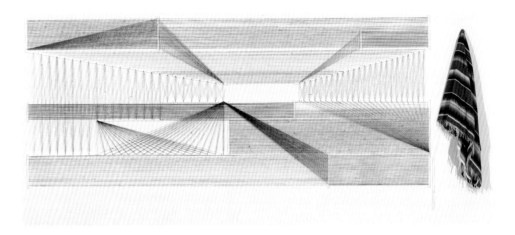

Adrian Esparza admits that "revealing the structure of an object" is at the core of his process. Using cheap *sarapes*, traditional Mexican blankets, his conceptual work amalgamates Pop Art's fascination with consumer culture and Chicano Art's concern with identity. Ubiquitous at Border region tourist stands and Tex-Mex restaurants, the *sarape* is instantly recognizable by its garish colors and quasi-indigenous design. Esparza literally unravels what he has termed this "functional symbol of Mexican kitsch" and then builds hand looms or wall guides to rethread new works. The owner of the *sarape* is left with detailed instructions to recreate the work once it is deinstalled. As such, Esparza questions what constitutes a work of art, what it means to create it, to own it, and commonly held institutional beliefs about display and interpretation.

Unlike his earlier *sarape* works, *One and the Same* responds to an existing work, which is in this case Audley Dean Nichols' 1922 *View Of El Paso at Sunset*, on display in the Museum's Tom Lea Gallery. Esparza reduces Nicols' panoramic sunset, framed by the Franklin Mountains into angled geometric forms while retaining the original scale.

Adrian Esparza studied at the Yale University Summer School, the University of Texas at El Paso, and the California Institute of the Arts. He lives and works in El Paso.

BF

One and the Same, 2005
Sarape, plastic trim and nails, 60 x 144"
Purchase with funds provided by the Robert U. and Mabel O. Lipscomb Foundation Endowment

JAMES EVANS
born 1954

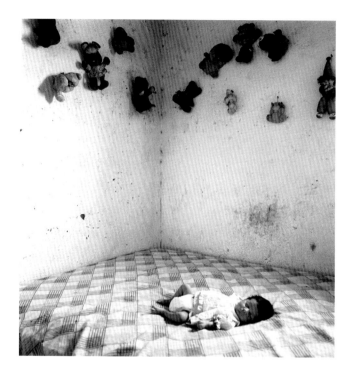

For the past twenty years, James Evans has photographed the landscape of the Big Bend region of Texas and the resilient people who live there. Each photograph by Evans reflects his belief that he is "a portrait photographer living in a beautiful landscape."

His landscape work is documentary as it captures reality in a personal way through details like a clothesline with goatskins hung to dry or a train crossing the desert under an isolated rainstorm. His portraiture, on the other hand, reveals Evans' uncanny ability to photograph his subjects in a manner that echoes the character of the wide-open country. Evans' *Border Baby* is a direct depiction of an unnamed baby living in the border town of Boquillas, Mexico. The interplay of the sleeping baby and the stuffed animals attached to the wall above poetically suggests the sweet dreams of the child, but the decrepit state of the bedroom implies that dreams may be all the child ever knows.

In addition to black and white, landscape, and portrait photography, Evans has created a series of psychological, still-life portrait photographs involving objects, animals, and insects such as snakes, tarantulas, and scorpions. His most recent work is a bit more abstract and concerns the movements of stars in night skies juxtaposed with artificially lit elements from the desert landscape below.

Evans was born in West Virginia, grew up in New Jersey, and lived in Philadelphia before moving to Marathon, Texas in 1988. Prior to devoting himself to his artwork, Evans photographed for many nationally published magazines. His photographs are in the collections of the Museum of Fine Arts, Houston; the Harry Ransom Humanities Research Center at the University of Texas at Austin; the Wittliff Gallery of Southwestern and Mexican Photography, as well as in many private collections.

CJG

Border Baby, 1997
Gelatin silver print, 15 1/2 x 14 7/8"
Gift of the artist

VINCENT FALSETTA
born 1949

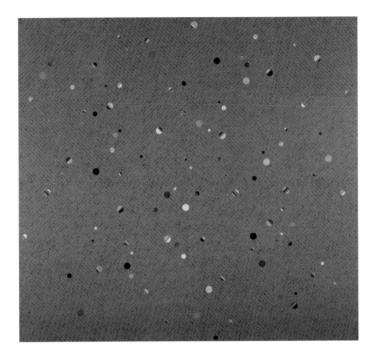

The paintings of Vincent Falsetta conjure diverse emotional responses that encompass Zen-like meditations on perfection or external readings of signs and symbols. Falsetta's art through the mid-1990s is balanced, engineered and modulated. It is presented within a cool palette of grays and browns, overlain with primary colors in a geometric, abstract language. The works evoke associations as varied as maps, constellations, or infinity. Vincent Falsetta grew up in Philadelphia. His parents emigrated from Italy, and he remembers as a child seeing sparks flying across the night sky from his Italian grandfather's ironworks. Falsetta also recalls watching his mother embroider and realizing that the lines of the threads were creating drawings on fabric.

Falsetta studied at Temple University and knew the art of 20th century abstract painters like Pollock, Kandinsky and Agnes Martin. His response both to the artists he knew and to his powerful childhood visual memories, is reflected in his controlled, patterned images. In 1997, Falsetta broke with his rigorously composed surfaces to create abstract images that experiment with flowing, looser shapes and forms. Vincent Falsetta knows that however planned and formulaic a work of art can be, when it is time to paint analysis gives way to intuition. As the artist said, "I have to let go for it all to work. If you don't let go, the spirit will be dead."

BDR

Untitled, 95-1, 1995
Acrylic on canvas, 69 ¹/₄ x 74 ¹/₄"
Purchase with funds provided by the Robert U. and Mabel O. Lipscomb Foundation Endowment

VERNON FISHER
born 1943

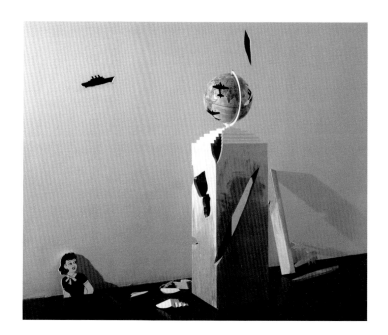

Finding meaning in artwork that combines text with painting, sculpture, photography, or found objects can be a challenge. For Vernon Fisher, such a predicament is intentional because it reflects a universal condition where meaning is never certain.

The Museum's collection contains four works by Fisher: an early graduate school painting, an installation, and two prints from the "Blackboards" series. In the 1970s, Fisher, influenced by the work of Californian artists Edward Ruscha and John Baldessari, developed an original style integrating personal narrative texts into realistic paintings of Texas roadside landscapes. The use of linguistic narratives has been a constant in his art ever since. In the 1980s Fisher began to work with installation art as shown in *Headhunter*, which consists of a globe placed on a partially-primed plywood pedestal with an assortment of cut-outs, shaped like boats and airplanes, extracted from the globe and pedestal and scattered on the background wall and floor. Utilizing the globe and the pedestal as art materials, Fisher deconstructs a longstanding feature of traditional art and an icon of modernism's accomplishments in order to offer another puzzle to be deciphered in the name of art.

Fisher currently teaches at the University of North Texas. In 1974, 1980, and 1981 he received Individual Artist's Fellowships from the National Endowment for the Arts. In 1995 Fisher received a John Simon Guggenheim Memorial Foundation fellowship to research site-specific installations. Fisher has been included in numerous group and solo exhibitions in the United States and internationally. His work is in many collections including the Museum of Modern Art, New York City; the Solomon R. Guggenheim Museum, New York City; the Art Institute of Chicago; the Museum of Fine Arts, Houston; the Dallas Museum of Art; and the Modern Art Museum of Fort Worth. He lives and works in Fort Worth.

CJG

Headhunter, 1988
Oil on wood and globe, dimensions variable
Gift of Ms. June Mattingly

CARMEN LOMAS GARZA
born 1948

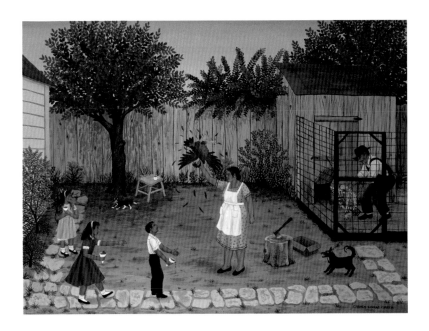

In the 1970s, when the first wave of Chicano artists was incorporating overtly political messages and pre-Columbian iconography into their work, Carmen Lomas Garza made a conscious decision to focus on the everyday life of her family. In her rich narrative paintings personal memory becomes the impetus for cultural history. Birthday celebrations, neighborhood dances, faith healings, and religious rituals are documented, presenting a compelling parallel to the overt racism and stifling poverty facing Mexican-American communities in postwar South Texas.

Para la cena (For Dinner) depicts the artist and her siblings in their grandparent's yard; the artist's grandmother stands poised to decapitate a chicken by swinging it from its neck. All three children gaze in awe at a powerful matriarch who holds life and death in her hands, a cycle understood early in rural childhoods. Garza's use of flattened figures and shallow picture space produce a sense of immediacy, allowing the viewer to actively participate in each scene. Although her paintings can sometimes become dreamlike, Garza avoids the sentimental. Dr. Tomás Ybarra-Frausto observes that Garza's works "keep alive the customs and daily practices that give meaning and coherence to Chicano identity."

Carmen Lomas Garza studied at Texas Arts and Industry University, Kingsville; Antioch Graduate School, New Hampshire; Juárez/Lincoln Center, Ciudad Juárez; and San Francisco State University. Born in Kingsville, she now lives and works in San Francisco.

BF

Para la cena (For Dinner), 1986
Oil on linen on wood, 24 x 32"
Purchase with funds provided by the Robert U. and Mabel O. Lipscomb Foundation Endowment

HARRY GEFFERT
born 1934

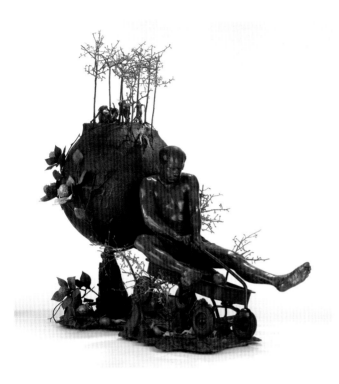

Through uncompromising experimentation, Harry Geffert has created a large and unique body of work. In 1980 he established the Green Mountain Foundry and has spent the past 25 years mastering traditional and hybrid casting techniques. *Mantime* is an example of his inventive sculptural technique and vision. Geffert culls from literary sources as well as his own imagination to explore subjects such as the relationship between man and nature.

Mantime is a dynamic work full of narrative potential and exploratory qualities. As the viewer approaches the sculpture, an important cast of characters appears. A magical earth-bound birth of humankind is on display. Figures are nestled in giant pea pods or climb out of small cocoons and crawl across the landscape. At the top of the sculpture, a group seems to be trying to take control of the world or is it their lives? A solitary figure reaches the water at the center of the scene. In the forefront, a lone, life-sized figure is descending downward into space on a child's wagon. The man seems to be seizing his life and letting go of his cares. By forgoing any attempt of control, the world is his to discover.

The plant life is shown in an array of patinas: browns, reds, greens, and yellows. The human figures are given an earth tone. The complex color scheme of this imaginary underworld contributes to the surreal, dreamlike and fantastical quality of the sculpture.

At Green Mountain, Geffert has worked with many artists that include Frances Bagley, Vernon Fisher, Joseph Havel, Ken Little and Linda Ridgeway. Geffert studied at New Mexico Highlands University and at the Southwest Texas State University in San Marcos. He lives and works in Crowley, Texas.

AG

Mantime, 2005
Bronze, 87 x 96 x 48"
Gift of the Barrett Collection in honor of Becky Duval Reese,
recognizing her contribution to the arts in El Paso

VIRGIL GROTFELDT
born 1948

A painter and an art professor, Virgil Grotfeldt was born in Decatur, Illinois, but has lived in Houston since 1977, creating a body of work that began with photo-realism and has since moved in the direction of biomorphic abstraction and spiritual mysticism. Since 1987 Grotfeldt has experimented painting with coal dust and other mineral powders mixed in acrylic medium gel. *Ringmaster* utilizes bronze powder adding a golden metallic sheen to an otherwise dark painting. Grotfeldt's painting method involves leaving part of the final image to chance because he cannot be certain how the powders he mixes will react with the gel medium. Therefore, the artist becomes something of a "ringmaster" himself, overseeing a process that he and nature guide.

Grotfeldt's influences include the hybrid creatures of the French symbolist painter Odilon Redon and the socially-concerned work of the German performance artist Joseph Beuys. In the introduction to a 2003 monograph on the artist, the well-known curator Walter Hopps said, "Nature and abstract form define Grotfeldt's art as well as sustain its value as a personal meditation upon essential life forces."

Grotfeldt received his Bachelor's in Art Education from Eastern Illinois University and his MFA in Printmaking at Philadelphia's Tyler School of Art in 1974. In 1999 he was the recipient of a grant in the visual arts from the Pollock-Krasner Foundation, and in 2003 he was selected as the Texas Artist of the Year by the Art League of Houston. His work has been exhibited in group exhibitions in China, Mexico, the Netherlands, and throughout the United States. Grotfeldt's work is in such prestigious collections as the Whitney Museum of American Art, New York City; the Museum of Fine Arts, Houston; and the Menil Collection, Houston. Grotfeldt lives and works in Houston.

CJG

Ringmaster, 1988
Acrylic and bronze powder on canvas, 91 3/4 x 75 1/2"
Gift of James Surls and Charmaine Locke

JOSEPH HAVEL
born 1954

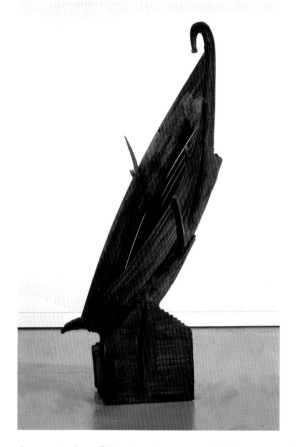

The career of Joseph Havel spans three decades over which he has explored a myriad of issues dealing with ideas of change, gender, and everyday life. His body of work encompasses many diverse and contradictory media, including cast bronze, ceramic, found objects, and custom-made shirt labels. Works in the collection of the El Paso Museum of Art represent the latter two categories.

Nocturnal Relations is a prime example of Havel's investigations with found objects about which he says, "A lot of my work has to do with transformation in one way or another, has to do with change. So I look for objects that will be changed and give a new dimension." *Nocturnal Relations* depicts a boat perched on a much smaller house. A circus wagon hitch forms the bow of the boat and the remainder of the piece is composed of scrap wood. Havel explains, "The narrative in broadest terms has something to do with the contrasting instincts to travel or change versus feeling rooted either in place, personality, or life situation." Evident in this work is the influence of three artists, Pop-art sculptor Claus Oldenburg and Surrealists Alberto Giacometti and Joan Miró, to whom Havel was exposed in graduate school. Like Oldenburg, Havel tends to focus on objects with daily human connotations.

Joseph Havel was raised in Minnesota. After completing his BFA at the University of Minnesota, and his MFA (Ceramics) at Pennsylvania State University, he joined the faculty of Austin College in Sherman, Texas in 1979. Since 1996 Havel has been Director of the Glassell School at the Museum of Fine Arts-Houston where he oversees the Core Residency Program, a coveted post-graduate award that provides studio space, a stipend to cover expenses, and valuable professional connections.

MDR

Nocturnal Relations, 1985
Found objects, wood and oil paint, 107 x 33 ½ x 56 ½"
Gift of James Surls and Charmaine Locke

BILL HAVERON
born 1957

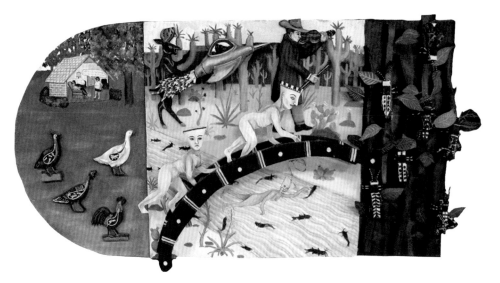

Bill Haveron views himself and his work as existing outside of the mainstream art world. Haveron draws, paints, and creates complex three-dimensional sculptures. This self-taught artist knows art, literature, and history. In his work, humor and satire are almost always present embedded in a rich assortment of images and characters. He comments, "For me, it is all about the work. The story. The message. This occupies the majority of my time. Dreaming, composing and doing the work." In *Where the Grasshoppers Live*, Haveron melds a *pastiche* of childhood memories with fiction. He positions himself here as the black retriever flying a rocket ship out of town. The work is at once personal and a quest for freedom.

Haveron's work has been exhibited in solo and group shows at the Meadows Museum of Fine Art at Southern Methodist University, Dallas; the McKinney Avenue Contemporary, Dallas; the Dallas Museum of Art; and the San Francisco Museum of Art. His work is included in the collection of the Austin Museum of Contemporary Art, the Dallas Museum of Art, the MTV studios, New York City, and the Museum of Modern Art, Fort Worth. Haveron lives and works in Fort Worth.

AG

Where the Grasshoppers Live, 1987
Mixed media construction, 22 x 46 1/2 x 7"
The Barrett Collection, Gift of the Museum of Fine Arts, Houston

BECKY HENDRICK
born 1947

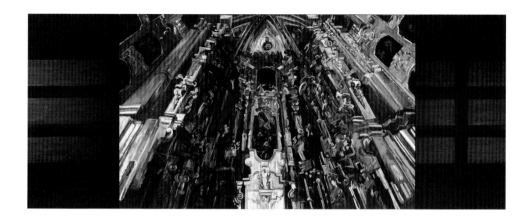

Becky Hendrick investigates questions of art and life as she continuously oscillates between various styles and media while approaching the same essential themes from various points of view. Hendrick's process results in works that may be visually distant, but are conceptually related.

The triptych *Invoke All Available Gods* is an example. The larger, inner panel depicts an upward view of a luminous, baroque altar rendered in a painterly, semi-realistic style that contrasts severely with the smaller, black, abstract panels that represent the *I-Ching's* Heaven and Hell.

In more recent work, Hendrick explores Dadaist concerns in paintings, performances, assemblages and videos that attempt to counterbalance the somber with the more light-hearted. Contrasting visual and conceptual opposites, Hendrick's work takes on political issues, solves formal problems and reveals the artist's enthusiasm for and understanding of art and its history.

Hendrick studied at the Instituto Allende in San Miguel de Allende, Mexico and received a MFA in 1978. Since 1985 Hendrick has taught art and art history at the University of Texas in El Paso. The artist lives and works in La Union, New Mexico.

AG

Invoke All Available Gods, 1990
Acrylic on canvas (triptych), 60 x 156"
Purchase with funds provided by the Robert U. and Mabel O. Lipscomb Foundation Endowment

ALEXANDRE HOGUE
1898-1994

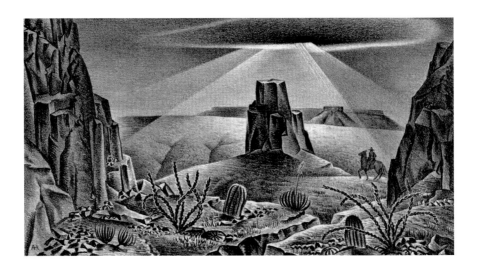

Alexandre Hogue gained national recognition with his paintings of the Dust Bowl region during the Great Depression, which were featured in *Life Magazine* in 1937. As a painter, printmaker and muralist, Hogue utilized a "combination of visual shorthand and memory" with a touch of the surreal. His preference in subject matter varied widely from the rituals of Native American life to the mundanity of ranch life. He abhorred the destruction of the Earth and condemned the lack of human reverence for the land, which is why he chose to portray the American landscape "not as an infinitely productive garden, but rather as a devastated and ruined wasteland created through human greed, misuse, and disrespect." During the 1920s and 1930s Hogue explored a new approach called "psycho-reality." Hogue explains, "Psycho-realism deals with the mental reality or reactions to real situations—not dreams or the subconscious—through careful use of imagination and symbolic forms." *Desert Glare* is an archetypal example of Hogue's work. With renderings of cactus, mountains, and the harsh sunlight of the southwestern United States, *Desert Glare* simply and quietly conveys a love of the land.

Hogue received formal training at the College of Art and Design in Minneapolis, following earlier study with Frank Reaugh. After returning to Texas in 1925, he became an influential member of the Dallas School (later the Dallas Nine) and a charter member of the Lone Star Printmakers. A dedicated educator throughout the majority of his career, Hogue most notably served as head of the School of Art at the University of Tulsa from 1945 to 1968. His contemporaries included Jerry Bywaters and Everett Spruce.

MDR

Desert Glare, 1945
Lithograph on paper, 6 3/4 x 11 3/4"
Purchase with funds provided by anonymous donors

BENITO HUERTA
born 1952

The words "Temporary like Achilles" are also the title of a 1966 Bob Dylan song. Huerta knowingly chose this title because he believes that it "alludes to being vulnerable at times" like the stack of red circles in the print that would be destined to collapse if they were balls. Huerta's complex print has several layers of imagery of a personal and universal nature that intentionally result in a complex, semi-abstract image.

Born in Corpus Christi, Huerta's Mexican and American heritage is the reason his artistic practice at one time had the business name *Flying Chalupa Productions*, and why he sometimes paints on "low-culture" black velvet. Huerta is an educated, informed artist whose work investigates the traditions of art and contemporary political issues and whether his iconography includes *chiles*, maps, Taoist *yin-yang* symbols, cartoon characters, or crosses, there are often multiple dualities in his work, reflecting his double heritage. During thirty years of art-making, Huerta developed the artistic philosophy that "Art is for everyone" and has become well known as a visual artist, curator, and writer. In 1994 Huerta was one of the founders of the Texas art journal *Artl!es*, and in 2002 he was selected as a Legend Artist by the Dallas Center for Contemporary Art.

Huerta holds a BFA from the University of Houston and an MFA from New Mexico State University, and has exhibited in both solo and group shows throughout the United States, in Croatia, and in Mexico. His paintings, drawings, and prints can be found in the collections of museums throughout the United States and his large-scale public artworks can be seen across Texas. The artist lives in Arlington.

BF

Temporary Like Achilles, 1999
Eight color lithograph plus blend, 30 ¹/₄ x 30"
Museum purchase

ANNA JAQUEZ
born 1953

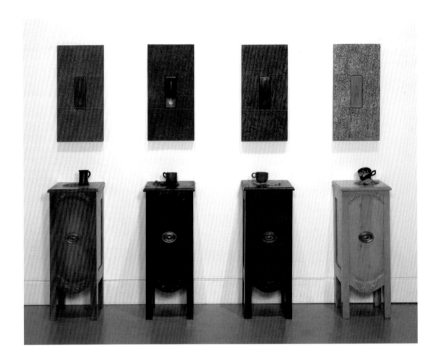

After years of making art jewelry, Anna Jaquez turned to sculpture. Her works, miniature *tableaux* installed in larger wooden structures are linked by delicate scale, technical skill, compositional structure, and masterful theatricality to the shadowboxes of Joseph Cornell and even the eggs of Peter-Carl Fabergé. In 1999, Anna Jaquez wrote that her art is driven by "the interplay of personal experience with the customs and beliefs of the Mexican people." Mining her own history, her works are poetic and confessional documentation, often dark, that explore "the tension between security of the home and childhood fears."

Her *Yerbas Buenas* (good herbs) series focuses on the homemade herbal teas central to *curanderismo*, a blend of homeopathy and faith-healing in Mexican culture. Centered on a particular herb, each of the four works is composed of a wooden nightstand with a mug. Inside each cup, Jaquez presents tiny domestic vignettes. *Cólicos* (cramps) features a figure huddled under the covers of a bed, the floor splitting open into a river of menses that abates at the nightstand holding a steaming tea. Spoons embedded in resin and mounted on panels behind each piece evoke both sacred reliquaries and throat lozenges. Manipulating the power of smell to cue memory, Jaquez integrates a hidden space for a votive candle underneath a metal drawer in each of the four pieces. Filled with cinnamon, chamomile, anise, and mint, the drawers gradually heat and perfume the space.

Jaquez scrolls text atop each nightstand as well with memories of childhood illness, drinking the teas, and the women in her life who administered them. Discussing this series, Jaquez reveals that "the aromas of the freshly brewed teas are as comforting and soothing as I remember my mother's and aunt's touch to be when I was ill. With age I have come to

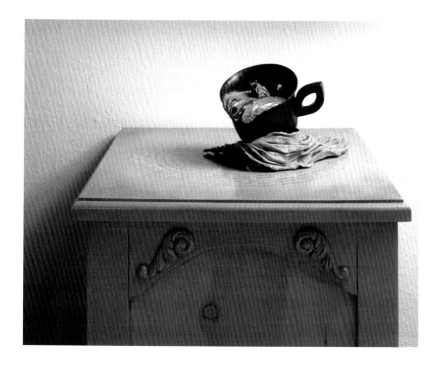

appreciate the wisdom and knowledge of these two very nurturing women. Having struggled with my own cultural identity, I find myself increasingly following their example." Ultimately, the *Yerbas Buenas* series functions as an altar, extending to pay homage to the healing powers associated with generations of women that are firmly ensconced in Mexican and pre-Columbian culture.

Anna Jaquez received her MA from the University of Texas at El Paso and her MFA from New Mexico State University. She lives and works in El Paso.

BF

LEFT (from left to right)

Mal Aire (from the *Yerbas Buenas* series), 1998-1999
Metal, wood, prismacolor, star anise, 65 x 12 $\frac{1}{2}$ x 13 $\frac{3}{4}$"

Dolor de Estómago (from the *Yerbas Buenas* series), 1998-1999
Metal, wood, prismacolor, mint, 65 x 12 $\frac{1}{2}$ x 13 $\frac{3}{4}$"

Estómago Revuelto (from the *Yerbas Buenas* series), 1998-1999
Metal, wood, prismacolor, cinnamon, 65 x 12 $\frac{1}{2}$ x 13 $\frac{3}{4}$"

Cólico (from the *Yerbas Buenas* series), 1998-1999
Metal, wood, prismacolor, chamomile, 65 x 12 $\frac{1}{2}$ x 13 $\frac{3}{4}$"

ABOVE
Cólico (detail)

Purchase with funds provided by the Robert U. and Mabel O. Lipscomb Foundation Endowment

LUIS JIMÉNEZ
1940-2006

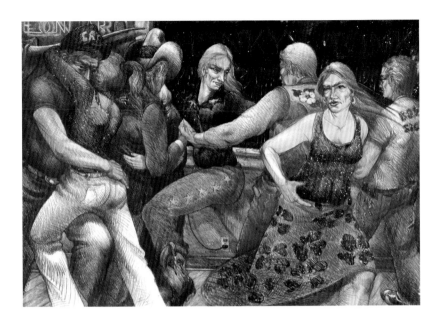

With ancestry in Mexico but roots in the United States, Luis Jiménez understood life from two points of view. Childhood observations and experiences coupled with the realization that the underclass is often left out of history prompted Jiménez to honor the disenfranchised through his art. Drawing on memories and stories of his immigrant father and grandparents, Jiménez bridged the generations in works that acknowledged their backgrounds and dignified their lives.

Luis Jiménez began securing public commissions during the 1970s that made socio/political statements on the status of Native Americans and Mexican Americans. By the late 1970s, he was an international success. He commented on his artistic vision by referencing regional writers like William Faulkner: "Every one of them focused on a very particular isolated situation that they knew well, and in so doing spoke also to broader issues."

In *Honky-Tonk*, Jiménez drew on recollections of a bar frequented by his father who by age 25 had become both a US citizen and a successful neon sign manufacturer. The younger Jiménez, who worked in the sign shop was often sent to bring his father home. The setting is a place of excess and sexual overture. Attention is given to the fleshy quality of the female forms as their clothes cling to their beer bellies and their breasts are barely contained within their blouses. Sensations of music, drink, dance and bawdy behavior are realized in a series of works that often place both father and son within the bar even though the son is always depicted as a voyeur distant and apart.

Honky Tonk, 1981
Lithograph with glitter, 35 x 50"
Purchase with funds provided by the Robert U. and Mabel O. Lipscomb Foundation Endowment

Following graduation from the University of Texas at Austin in the early 1960s, Jiménez traveled to Mexico City with the idea of studying there and immersing himself in the history of Mexico. After a short stay, he moved to New York City where he lived until the late 1970s. During the turbulent time of the late 1960s, Jiménez was discovering his unique voice in his response to the Vietnam War or aspects of American culture that he found to be hypocritical. In parodies like *Barfly-Statue of Liberty*, the artist honed his concept of the female figure: she is voluptuous, bursting with overt sexuality. She appears drunk and out of control. The nation's symbol, the American flag, is draped beneath her and she lifts her beer mug just as the Statue of Liberty lifts her torch.

Throughout his career, Luis Jiménez sought to glorify—even to sanctify—the working class. He eulogized everyday heroes who labored, fought and died for their country. He brought praise to Americans who were often overlooked.

Luis Jiménez studied at Texas Western College (now the University of Texas at El Paso), the University of Texas at Austin, and Ciudad Universitaria in Mexico City. His work is in numerous public and private collections. Of his many public art commissions and awards, several are from the National Endowment for the Arts. In 1979 Jiménez became a fellow of the American Academy of Rome.

BDR/AG

Barfly - Statue of Liberty, 1969
Acrylic on fiberglass, 88" high
Gift of Suellen and Warren Haber

DONALD JUDD
1928-1994

Donald Judd is considered a leader of the Minimalist art movement. Early on, he promoted the understanding of minimalism through his writings in *Arts Magazine* and *Art News*. However, Judd strongly rejected the term Minimalism for his own work. Instead, he wanted people to understand his work as a simple expression of a complex thought. In the early 1960s he moved away from painting to sculpture and architecture. His mature aesthetic emerged, and by 1965 Judd's work was very well known. He promoted an art that was reduced to basic forms without unnecessary elements. Known primarily for his sculptural work, Judd explored the dichotomies of positive and negative space. This aquatint on paper, *Untitled*, is emblematic of these values.

Judd's ideas about architecture, philosophy, and design were brought to fruition with non-traditional industrial materials and techniques. He typically constructed his three-dimensional pieces with steel, concrete, and plywood. While *Untitled* is a two-dimensional work on paper, it is a formal composition that can be read as a dynamic three-dimensional structure. The dark forms contrast and define the light forms. Judd strips away pretense and expectation, challenging the viewer.

Judd was born in Excelsior Springs, Missouri. He studied at the Art Students League in New York City; the College of William and Mary in Maryland; and Columbia University in New York City. He taught and lectured widely, received numerous awards, and is in many international collections. Judd's work has been exhibited in such venues as the Whitney Museum of American Art, New York City; the Venice Biennale; and the Solomon R. Guggenheim Museum, New York City. Judd worked to create a permanent space for his work in Marfa, Texas, which remains a rich legacy for his work as well as that of other contemporary artists.

AG

Untitled, 1974
Aquatint on paper, 41 x 29 ¼"
Purchase with funds provided by the Robert U. and Mabel O. Lipscomb Foundation Endowment

HARI (Harry) KIDD
1899-1964

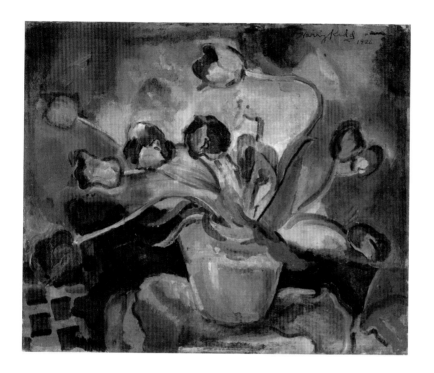

Born in El Paso, Hari Kidd embraced European Modernism but retained an interest in the subjects of Regionalism. Kidd studied at the Philadelphia Academy of Fine Arts, receiving a scholarship to travel to Spain and Paris. Returning to El Paso in 1933, he painted constantly and continued to exhibit in Philadelphia, as well as in Houston, Dallas, and San Antonio. One critic, commenting on Kidd's tendency towards abstraction wrote in 1939 that the artist "is a painter of rich, imaginative qualities, [who] uses an unusual method of procedure in the fashioning of his pictures, and is one to whom the mere 'prettification' of any subject is abhorrent."

In the early 1940s, Kidd left El Paso for an extensive trip through Mexico, a Modernist mecca that was drawing some of the most progressive artists and intellectuals from the U.S. and Europe. Absorbing the influences he encountered, including those of the Mexican muralists, Kidd's works from this period garnered national acclaim. This new work culminated in a one-man exhibition, *Mexican Scene*, depicting people, scenes, and politics of Tehuantepec and Ixtepec, exhibited at Rockefeller Center in 1944. As a result of his studies and travels, Kidd possessed a solid understanding of Modernism. In particular, Kidd admired Expressionism and Fauvism; *Tulips* shows the influence of both Cézanne and Matisse.

ABP

Tulips, 1926
Oil on canvas, 19 ½ x 23 ¼"
Gift of the Estate of Bertha Thomlinson

GEORGE KRAUSE
born 1937

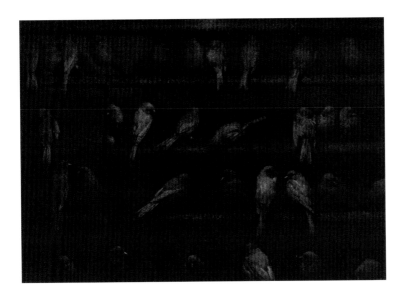

Birds, Mexico exhibits Krause's passion for ordinary moments that emerge as extraordinary. It might appear quite simple at first, but Krause pondered the composition and final image for several years before ultimately producing this print. Birds, Mexico is from The Street series, one of five major series that Krause has worked on in the past forty years. Well known for the technical virtuosity of his gelatin silver prints, Krause's subtle handling of light and his concentration on mortality infused with a melancholic mood are hallmarks of his work. Krause also often includes discrete references to the history of art in his work. For example, his I Nudi series pays homage to the Classical sculpture found in Rome but also has an affinity for Surrealism.

Since 1997 Krause has worked on The Sfumatos, a portrait technique utilizing a custom-made "light box" to backlight his sitters enveloping them from behind in a cloud of light and throwing their physiognomies into partial shadow.

Krause studied at the Philadelphia College of Art and served in the U.S. Army from 1957 to 1959. Coincidentally, his earliest experiments with photography began in the army, when he became a military counterintelligence photographer. From 1975 to 2001, Krause was the Director of Photography at the University of Houston. He has received many grants and awards, including three from the National Endowment for the Arts, two Guggenheim Fellowships, and the first Prix de Rome in photography. Krause's work has been exhibited nationally and internationally in more than fifty solo exhibitions and in major retrospectives at the Museum of Fine Arts, Houston and the Philadelphia Art Alliance. Krause's work is represented in significant collections such as the Museum of Modern Art, New York City; the Library of Congress, Washington D.C.; and the Bibliotheque Nationale, Paris. The artist lives in Wimberley, Texas.

CJG

Birds, Mexico, 1965
Gelatin silver print, 6 7/8 x 8 3/8"
Purchase with funds provided by the Marian Meaker Apteckar Foundation

CHARLES MARY KUBRICHT
born 1946

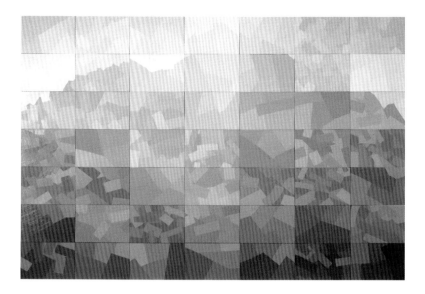

Charles Mary Kubricht recalls: "when I first started doing landscape, I knew it had a lot of historical baggage and it would be very difficult to represent the landscape in a new way." Indeed, the tradition of landscape painting in the American West, dominated by artists such as Albert Bierstadt and Thomas Moran in the 19th century, emphasizes the grandeur of nature and the heroics of expansion. Kubricht has subverted the weight of the genre by removing the political and emphasizing the experiential in her highly evocative, large scale, multiple panel paintings that seek to capture the ephemeral.

Kubricht avoids painting outdoors, although her process begins with an extensive hike recorded with hundreds of photographs. Paintings like *Mountain* are the result of a selected photograph that has been carefully divided into a grid. Each section is self-contained; paint is thickly applied, and brushstrokes are often large. This mathematical breakdown of space transposed onto multiple, highly individual panels allows Kubricht to explore subtle variations of color, light, movement, and even time in a single "shot" that is best resolved when the viewer approaches these works from a distance. With her abstractions grounded in figural representation, Kubricht does not seek to provide a literal documentation of nature, but rather of her own time spent in it. "I'm experiencing the land…what I want to do is simulate the intensity of the experience I've had."

Charles Mary Kubricht studied at Queens College in North Carolina; the Institute of European Studies in Vienna, Austria; and the University of Houston. Kubricht was also a member of the Core Residency Program of the Glassell School of Art of the Museum of Fine Arts, Houston. She divides her time between Houston and Marfa, Texas.

BF

Mountain, 2001
Acrylic on 49 wood panels, 70 x 105"
Gift of Adair Margo Gallery

IDA G. LANSKY
1910-1997

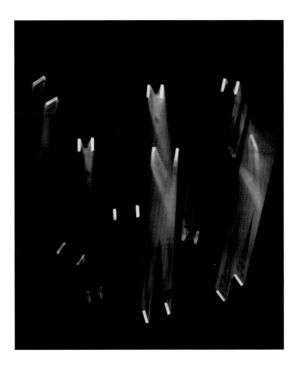

Ida Lansky was one of the pioneers of Modernist photography in Texas. Her creativity was inspired by Carlotta Corpron, who also introduced her to the avant-garde aesthetics of the Bauhaus. Lansky was most active with photography between 1954 and 1960, when she produced a relatively small, but important body of work that explores photography as a creative art form through the use of nearly every experimental photographic process known at the time. Lansky had a unique ability to understand the chemistry behind photography, which allowed her to record her investigations in detailed notebooks.

Although Lansky's earliest photographs were not experimental and were what Lansky categorized as "regular" photographs, they definitely show an interest in reflection, distortion, and abstraction. Jets is one of a later series of photograms that Lansky made using clothespins and whose abstraction, movement, and title change the viewer's perspective. Lansky should be categorized among the relatively few artists whom at mid-century thought of photography as an exploration of creative image-making possibilities rather than as an act of representation.

In 1959 Henry Holmes Smith invited Lansky to participate in a group exhibition titled *Photographer's Choice* at the Art Center Gallery at Indiana University, Indianapolis. Lansky loaned three photographs to the exhibition, which included well-known photographers such as: Ansel Adams, Harry Callahan, Clarence John Laughlin, Nathan Lyons, Eugene Meatyard, Aaron Siskind, Frederick Sommer, and Minor White. In 1960 Lansky exhibited her "experimental abstractions" in Dallas and San Francisco.

Lansky was born in Toronto, Canada and moved to New York City in 1928 to study at New York University, where she later received a Bachelor of Science degree in Public Health Nursing. From 1954 to 1959, she studied visual art at Texas Woman's University in Denton. After 1960 she chose Library Science as a career.

CJG

Jets, c. 1950s
Gelatin silver print, 8 ⁷/₈ x 7 ¹/₂"
Purchase with funds provided by the Marian Meaker Apteckar Foundation

TOM LEA
1907-2001

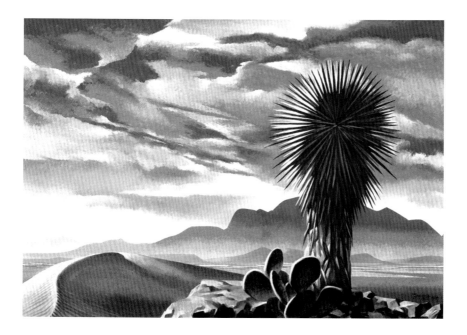

His muse was his hometown. His vision and voice were based on the landscape of desert and mountain, its history and its heroes. He told stories on paper and canvas and was successful both as artist and author. Tom Lea's art serves as a song to a unique place in Texas. El Paso is a city of two countries and three states. The Rockies and Sierra Madres converge here. The land is sensual with the fragrances of the desert and multiple languages describe the same vista. Tom Lea, though widely traveled, was born, raised, lived, and died in El Paso. He studied at the Art Institute of Chicago but returned to the Southwest to make his art and earn his living.

Tom Lea's earliest commissions were for murals. The life-size drawing for the mural *Pass of the North* records the history of settlement of this region. Explorers, pioneers, plainsmen, ranchers, farmers, representatives of church and state make up Lea's panorama, which records El Paso's beginnings. The mural *Pass of the North* is on view at the United States Court House, El Paso.

In *Sarah*, the artist presents a civilizing symbol of the West. Seated in front of a mountainous and empty landscape, the figure's direct gaze strongly engages the viewer. Dressed in desert colors, she holds a book in her hands. Strength and intelligence permeate the painting, which assures that this human presence is as solid and stable as the land upon which she dwells. Often serving as model to her husband, one can almost feel the respect and love Lea

Rio Grande, 1954
Oil on canvas, 22 ¹/₄ x 32"
Gift of Mr. and Mrs. Robert W. Decherd in honor of Isabelle Thomason Decherd and H. Ben Decherd

TOM LEA
continued

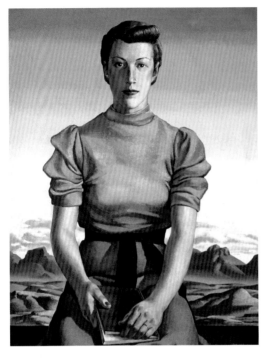

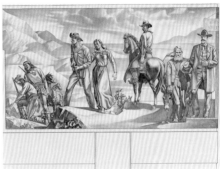

held for his wife Sarah. In his landscapes Lea represents the land in a primordial way. The simple forms of *Rio Grande* capture the essence of this region: large expanses of open space, big skies, and cactus standing sentinel. Painted in a limited palette of browns and blues, the pigment is laid on almost like the stucco of local dwellings.

Tom Lea was a muralist, easel painter, war correspondent/illustrator, writer of history and fiction, and at heart, a humble man. He sought truth and recorded it. Through his eyes, we too,can know better and understand this unique place in the Texas desert.

BDR

Sarah, 1939
Oil on canvas, 34 ¼ x 26 ¼"
Gift of the IBM Corporation

Pass of the North Mural Design, 1937, (right detail)
India ink, graphite and charcoal on paper, 31 ¾ x 107"
Gift of Mr. Erwin H. Will, El Paso Electric Company

ANNABEL LIVERMORE
born 1940s

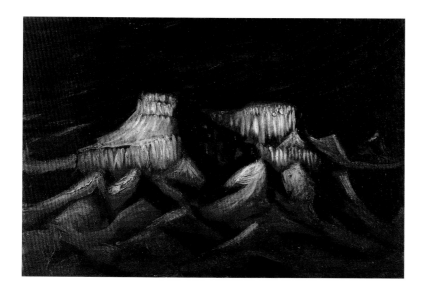

Big Bend III is a mysterious night scene that captures the last rays of light illuminating a rugged desert landscape. It is interesting to imagine what would influence a retired librarian from the Midwest to venture into the Texas desert to paint at night. Livermore's visionary landscapes from the *Big Bend* series and the more recent *Jornada del Muerto* series are evidence of her awe at the immensity of these regions' ever-changing skies and their history-laden terrain.

Annabel Livermore's world is revealed through the joy of painting. Her painting technique is comparable to that of Vincent Van Gogh and typically features thick impasto paint. In contrast to nineteenth century Post-impressionists, Livermore's subjects transcend nature's wonder as they reveal romantic, symbolist-inspired spiritual images that portray figures, animals, and architecture as participants in unexplained narratives. Livermore supplements her paintings with her poems, which stand in for titles and signify her admiration for English artist William Blake.

Livermore claims that her art is all about El Paso and the areas that surround it. This is certainly evident in the glowing flower watercolor paintings executed in her backyard garden studio as well as in her genre *N Bar* (1987-1990) and *Desert Dream City* (1998-2001) series, resulting from visits to the seedy bars, plazas, and marketplaces of Ciudad Juárez.

Annabel Livermore is frequently said to be James Magee's "alter ego." Since the mid-1980s she has worked through him, never appearing in public, and only recently did Magee reveal the fact that they inhabit the same body and are "inseparable friends." Annabel's first exhibition was in 1986. Since then she has exhibited in many group and solo exhibitions throughout the United States. Annabel lives in El Paso and maintains studios there and in Hillsboro, New Mexico.

CJG

Big Bend III, 1995-97
Oil on panel with handmade frame, 31 x 47"
Purchase with Funds Provided by Richard and Nona Barrett, Robert and Margaret Belk,
Mr. and Mrs. Tim Handley, and the Robert U. and Mabel O. Lipscomb Foundation Endowment

JAMES MAGEE
born 1946

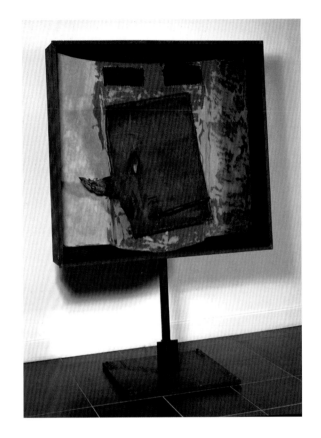

James Magee is best known for abstract assemblage sculpture made out of steel, glass, wax, grease, oil, and other industrial waste materials found in the dumps of El Paso and Ciudad Juárez.

The mixed media work *Lorenzo*, evinces the philosophical and aesthetic concerns found in Magee's work, such as the passage of time, the ephemeral nature of life, and the language of abstraction. *Lorenzo* has a self-supporting base made of heavy gauge steel and is constructed as a shadowbox. The objects behind the front pane of glass—the bondo-covered automobile hood, the rusting freight-car door, and the collaged pieces of a Mexican crime magazine—challenge the viewer to define where the artwork ends and the "frame" begins. The viewer may face a further intellectual *impasse* when listening to the spoken-word poem title for *Lorenzo* as it is considered to be an integral piece of the work. Magee has explained that his "visuals are abstract and his titles are narrative."

James Magee was born in Fremont, Michigan. He received a Law degree from the University of Pennsylvania in 1971 and hitchhiked throughout Africa until beginning a one-year apprenticeship with sculptor Caroline Lee in Paris, France. For the next nine years Magee worked at various jobs to support his art-making. Since 1980 Magee has lived in El Paso producing a body of work that seems to ask, "Where else but El Paso?"

Magee's work has been seen in numerous solo exhibitions including the Contemporary Arts Museum, Houston; the Dallas Museum of Art; the Santa Monica Museum of Art; and the Yale University Art Gallery, New Haven.

CJG

Lorenzo, 1990
Automobile hood, bondo, paper and paint, 88 x 60 x 30"
Purchase with funds provided by the Robert U. and Mabel O. Lipscomb Foundation Endowment

JOE MANCUSO
born 1954

A muted palette, cognitive interest in material, avoidance of the extraneous, and belief in the primacy of pure form have all firmly linked Joe Mancuso's concerns to those of Minimalism. Mancuso dissents from Minimalist strictures by consciously imbuing his sculptures, paintings, and installations with the personal. Comfortable in a variety of media, Mancuso emits a quiet elegance in his works.

Cone is part of a larger series of *tondo* paintings exploring the rhythm and substantiality of concentric circles. Working from the outward edge, Mancuso paints bands, revealing the artist's hand with shifting pressure and irregularities. Moving inward, each circle builds on the layers of bands before it. Through this laborious process, the painting's center is thicker than the periphery, allowing the work to subtly function as its title suggests. As a result, *Cone* exists in a transitory space between painting and sculpture.

Joe Mancuso was born in Hibbing, Minnesota. He received his BFA from Colorado State University in Fort Collins and his MFA from Indiana University, Bloomington. He lives and works in Houston.

BF

Cone, 1994
Acrylic on canvas on panel, 72" diameter
Gift of Alton and Emily Steiner

MANUAL

a.k.a. Suzanne Bloom, born 1943 and Ed Hill, born 1935

Walking East of Ricker's Field/Composition Chequerboard, Mondrian is a recent work by MANUAL and may be thought of as the tip of an electrified iceberg representing a much larger body of work that spans more than thirty years and includes media as diverse as photography, video, and computer-generated imagery. Through the introduction of new time-based art forms in the 1960s and 1970s, the theory-filled textual postmodernism of the 1980s, and the digitized technologies of the 1990s MANUAL has continually created work that questions the nexus of art and technology and comments on culture and environmental issues. A computer produced grid of three hundred and four still video images of a figure walking through a landscape, *Walking East of...* is colorized in the upper two-hundred and fifty frames to suggest the work of Dutch artist Piet Mondrian. In addition, *Walking East of...* is specifically related to a 1970s MANUAL video work titled *Running in Ricker's Field Slowly*, 2002, showing MANUAL's art through previous art and through nature.

Whether existing as digitally altered photography, videos, or online web-based projects, MANUAL emphasizes Lucy Lippard's famous words from her 1973 book *Six Years: the Dematerialization of the Art Object from 1966 to 1972*: "It isn't really a matter of how much materiality a work has, but what the artist is doing with it."

MANUAL, as an artist name, was adopted by the collaborative artists Suzanne Bloom and Ed Hill in 1974 to reference the dual meanings of art as a manual task and as a guiding text. Bloom started out as a painter and Hill as a printmaker. Both have been teaching at The University of Houston since 1976. They have exhibited extensively nationally and internationally and live and work in Houston and Vermont.

CJG

Walking East of Ricker's Field/Composition Chequerboard, Mondrian, 2004
Archival pigment print, 43 1/4 x 44 3/4"
Purchase with funds provided by the Robert U. and Mabel O. Lipscomb Foundation Endowment

BARBARA MAPLES
1912-1999

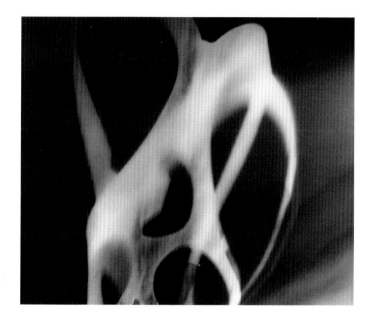

Barbara Maples was already an accomplished painter, printmaker, and ceramicist who had participated in numerous exhibitions and whose work was in art collections around the country when she began to work with photography. Her photographic work was influenced by her mentor, Carlotta Corpron with whom she studied at Texas Woman's University in the late 1960s. Maples' photography transcended the traditional uses of photography as she worked in a mostly abstract Modernist style inspired by European, avant-garde aesthetics.

Barbara Maples created a fascinating body of work, but relatively little of it has been seen by the public. She loved experimenting and is best known for her photograms of constructed environments. *Smoke* is one of four Maples photographs in the Museum's collection and was produced using a constructed environment. In order to photograph only a wisp of smoke and obtain the desired effect, Maples used a dark background and projected light onto the smoke. When she was not photographing constructed environments she made photograms, images created without a camera by placing simple objects such as feathers and bent wire between light-sensitive paper and a light source. Her primary subject was light and the formal design compositions she could emphasize with it.

Barbara Maples was a graduate of Baylor University and received her MA in Art Education from Columbia University in New York City. She taught art in public schools in Temple, Fort Worth, and Dallas from the 1930s until 1965 when she became the Head of Art Education at Southern Methodist University in Dallas where she remained until 1978. Maples also taught art classes at the Dallas Museum of Fine Arts School from 1940 to 1954. Her photographs were shown once in Dallas in a 1990 exhibition titled *Photographic Abstractions: Barbara Maples & Carlotta Corpron*.

CJG

Smoke, c. 1967-68
Gelatin silver print, 7 ⁷/₈ x 9 ³/₈"
Purchase with funds provided by the Judith Rothschild Foundation

CESÁR MARTÍNEZ
born 1944

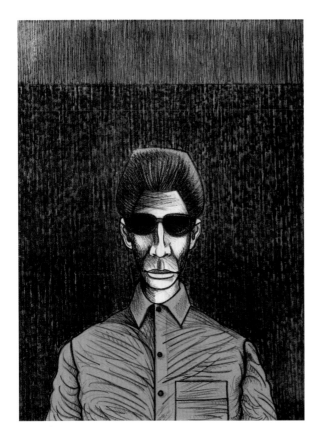

While critical interest in portraiture waxes and wanes, many contemporary artists continue to create works within this traditional genre. César Martínez is a painter and printmaker from Laredo, Texas. He draws from childhood memories and utilizes yearbook photographs as well as newspaper and magazine depictions of cultural icons as sources of inspiration. He has produced and is well known for a large body of work in which the figure in half-length frontal view takes prominence.

Culturally, the people of the *barrio* (neighborhood)—the friends, neighbors, and relatives of César Martínez would recognize the figure in *Bato con Sunglasses*. In this portrait Martínez explores the issues of identity and self-cultivation. The symbols within are identifiers of early *Pachucos* (Zoot Suiters) of the 1940s—a subculture that continues today in various incarnations. Like many of Martínez's works *Bato con Sunglasses* has a title that includes words in both Spanish and English. This *bato* (guy or pal) appears to be in charge of his destiny, or at the very least, his appearance. He is the tough guy, the outsider, yet he is a man with a thin neck perhaps trying too hard not to appear vulnerable.

César Martínez studied at Laredo Junior College in Texas and at Texas A&M University in Kingsville. He made early strides within the Chicano art movement in the 1970s and 1980s. He has had solo and group exhibitions at venues such as the San Angelo Museum of Fine Art; Art Pace, San Antonio; the Art Museum of South Texas; the Tucson Museum of Art; the National Collection of Fine Art at the Smithsonian Institution, Washington D.C.; and the Museum of Contemporary Art, Chicago. His work is in numerous public and private collections. Martínez lives and works in San Antonio.

AG

Bato con Sunglasses, 1990
Lithograph, 30 x 30"
Gift of MARS Artspace

MERRITT THOMAS MAUZEY
1898-1973

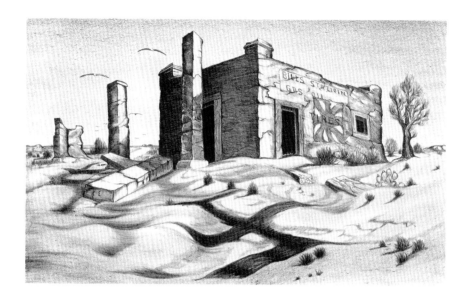

"I think my somewhat primitive, awkward drawing has removed my lithographs from the common stereotype...but I feel like it has added earthiness to all my art, for all my art comes from the earth of my early days." Seeking to reflect universal statements from the hard-scrabble environment that generated his earliest memories, Merritt Mauzey's regionalist style derived its strength and power from the land he knew well. Mauzey was born in Clifton, Texas and by 1900 had moved in a covered wagon with his family to Oak Creek Valley. By 1912 Mauzey lived with a married sister in Blackwell in order to attend high school and began to study drawing through a correspondence course. In 1927 the family moved to Dallas, and in his spare time Mauzey studied etching with Frank Klepper. Mauzey's art was included in the 1936 Texas Centennial Exhibition and he was a charter members of the Lone Star Printmakers. Mauzey's prints were noticed by Carl Zigrosser, a staff member of the Philadelphia Museum of Art and a specialist in American printmaking. In 1942 Mauzey's images were included in Zigrosser's *The Artist in America: Twenty-four Close-ups of Contemporary Printmakers*. Recognition through the publication led to Mauzey's 1946 receipt of the first Guggenheim Foundation fellowship awarded to a Texas artist.

In *West Texas*, Mauzey records an abandoned gas station near Fort Davis and incorporates the symbols of the Nazi swastika incised on the earth and the Rising Sun flag of Japan decorated on its wall. In a similar print held by the Museum of Texas Tech University, the work is titled *Challenge*. Merritt Mauzey's image becomes war-time propaganda signaling the dangers of fascism.

BDR

West Texas, circa early 1940s
Lithograph, 12 ¹/₂ x 19"
Purchase with funds provided by museum docents in honor of Lori Eklund

MARY McCLEARY
born 1951

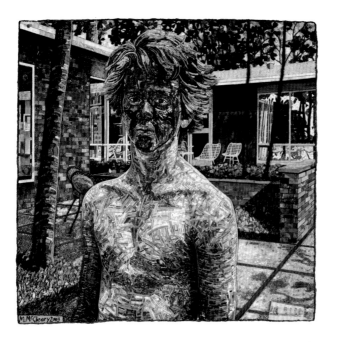

The convergence of popular culture with traditional subjects associated for centuries with high art is the paradoxical core of Mary McCleary's art. As theorist André Félibien advocated in his 1669 treatise on the hierarchy of genres, McCleary's narrative subjects draw from ageless struggles of good and evil, holiness and temptation, and struggle and redemption found in biblical, mythological, and literary sources. Deviating from tradition, weighty archetypes such as Abraham and Isaac, Icarus, and Potiphar's wife are cast in contemporary suburban and rural vernaculars. Bits of painted wood, twisted scraps of paper along with such mundane items as erasers, trinkets, glitter and beads are layered over base paintings to create large-scale virtuosic collages. McCleary's choice of media is a deliberate means of incorporating "the trivial, foolish and temporal to express ideas of what is significant, timeless and transcendent."

A line from T. S. Eliot's 1922 poem *The Wasteland* is the title source of *Jerusalem, Athens, Alexandria, Vienna, London*. The poem, illustrating a soul in isolation, is heavy with literary and historical allusions. McCleary embeds lines from *The Wasteland* in the work as well as text from Joseph Conrad's 1902 novel, *Heart of Darkness*, which explores the dangers of imperialism and the basis of human nature as primitive. McCleary personifies the struggles of isolation and primal awareness as an adolescent boy in a suburban backyard, his face painted to resemble a warrior. As with her best works, McCleary successfully integrates the personal, leaving room for viewers to bring their own points of reference to specific allusions. Awkwardly staring out, McCleary's warrior is a reminder of the universal feelings of isolation, self-doubt, and "primal" behavior that typifies adolescence.

Mary McCleary studied at Texas Christian University and the University of Oklahoma, Norman. She lives and works in Nacogdoches, Texas.

BF

Jerusalem, Athens, Alexandria, Vienna, London, 2003
Mixed media collage on paper, 31 ¹/₄ x 31 ¹/₄"
Members' Choice Purchase

BLANCHE McVEIGH
1895-1970

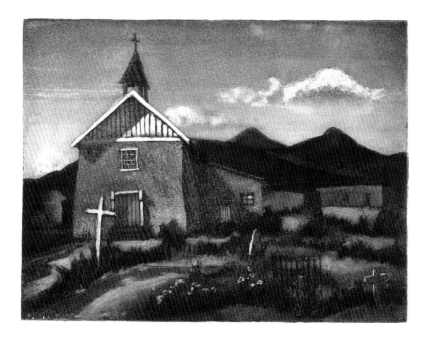

Born in Missouri but reared in Fort Worth, Blanche McVeigh left her mark on the regional art scene through her prints, which serve as records of mid-20th century life and times. McVeigh graduated from Washington University in Missouri but decided several years later to become a professional artist. She studied at the Philadelphia Academy of Fine Arts and at the Art Institute of Chicago and the Art Students League in New York City. McVeigh traveled in Europe and during her sojourn discovered the medium of aquatint, which she employed thereafter.

In 1932 McVeigh joined with Fort Worth artists Evaline Sellors and Wade Jolley in establishing the Fort Worth School of Fine Arts where she taught figure drawing and etching. McVeigh was a member of numerous artist groups, but it was through her involvement with the Texas Printmakers that her art received national recognition. Formed when women were denied membership in the Lone Star Printmakers, the women organized exhibitions of their prints for the next 25 years, and sent them on circuits, which were shown in museums, libraries and colleges across the United States. During her summer vacations, McVeigh traveled and often recorded with keen appreciation and sensitivity the places and cultures she observed. *Church, Arroyo Secco, New Mexico* records such an image made during one of Blanche McVeigh's journeys across the Southwest.

BDR

Church, Arroyo Secco, New Mexico, 1948
Color aquatint and etching, 12 ¹/₈ x 15 ¹/₂"
Purchase with funds provided by the Robert U. and Mabel O. Lipscomb Foundation Endowment

MELISSA MILLER
born 1951

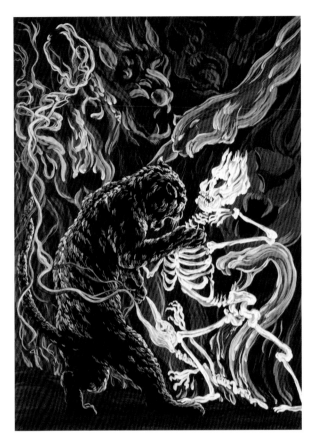

Melissa Miller gained national fame in the early 1980s as part of a wave of figurative artists who rejected decades of experimentation in favor of more traditional approaches to painting. Sharp tonal shifts, bravura color, heavy brushwork rich with impasto, and a decided bent towards the supernatural and catastrophic characterize Miller's work from this period. Most definitive is Miller's use of animals as allegories for human folly and struggle, a narrative device linked to the fables of Aesop and La Fontaine. Initially painting family pets and farm animals, she soon began to incorporate wilder species in her works. She reflects, "I never developed the vocabulary for humans that I did for animals, so I stopped using them when I realized that animals could carry the narrative." Miller's menagerie of wildcats, baboons, and birds is consistently given a mystical treatment, eliciting critic Michael Brenson's fitting comparison to both Jackson Pollock and William Blake.

Ablaze belongs to a period in the mid-1980s when the animal conflict in Miller's work is manifested as a spiritual, rather than physical, struggle. The work is especially significant as Miller's first venture into the print medium, a collaboration with the University of Texas at Austin's Huntington Art Gallery's (now the Jack S. Blanton Museum of Art) Guest Artist in Printmaking Program. In order to preserve her signature brushwork and tonal shifts, twenty-one photoscreens were used for each print, mimicking Miller's laborious eighteen-month painting process.

Melissa Miller attended the University of Texas at Austin, the University of New Mexico, and Yale University's Summer School. She lives and works in Austin.

BF

Ablaze, 1986
28 color serigraph, 40 x 30"
Purchase with funds provided by museum docents and the Robert U. and Mabel O. Lipscomb
Foundation Endowment in honor of Mr. Robert A. Kuegel

MARK MONROE
born 1959

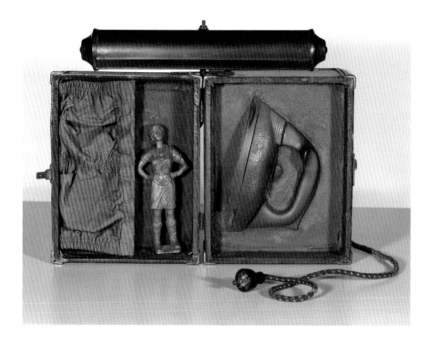

Sherman, Texas artist Mark Monroe works frequently with found objects. Mixed media sculptures in the collection of the El Paso Museum of Art, *Mis-Fit* and *Endless Appliance Column*, are both a part of this genre. *Mis-Fit* incorporates a vintage suitcase, a standard picture frame light, and relief sculptures of a woman fully equipped with a dagger, pistols, and a clothes-pressing iron. To the viewer it appears as if the woman is on a stage, the orange pocket of the suitcase serving as her curtain. With her confident pose and accoutrements, she is ready to challenge anyone and anything that comes her way. Monroe worked from 1987-1991 as an assistant to noted sculptor James Surls. Surls' influence is evident in Monroe's work through his approach and choice of projects. Both artists demonstrate an understanding of the poetry of the common object while presenting a fresh look at everyday utilitarian items.

Monroe currently serves as an Associate Professor of Art and as the Chairman of the Department of Art at Austin College. He received his BA from Austin College and MFA in Sculpture with a Minor in Art History from the University of Texas at Austin. Monroe worked with Christo and Jean Claude in 2004 on *The Gates* installation in New York City. He continues to work with sculpture in its many different forms.

MDR

Mis-Fit, 1990
Mixed media, 15 x 19 ¹/₂ x 7"
The Barrett Collection, Gift of the Museum of Fine Arts, Houston

KATRINA MOORHEAD
born 1971

Somebody Else's Salton Sea (Moonlite) is an inexact model of a motel swimming pool found near the small, resort towns along California's largest and saltiest lake, the Salton Sea. Each work in this series is named after those small motels, (in this case the *Moonlite*), whose towns once provided recreation to old Hollywood, but are now nearly abandoned.

Moorhead's sculpture, like many of her other works, speaks directly about utopian ideals and changing notions about nature. Dealing with issues that may be locally specific (the economy of a small, resort town) or internationally important (the use of the natural resource—water or the human responsibility for environmental change), Moorhead transforms the everyday into art. Most recently, Moorhead recreated the gull-wing doors of the ill-fated DeLorean automobile out of wood with an inverted ballroom ceiling complete with lighted fixtures and a graffiti-based, floral text proving that her idiosyncratic synthesis of history, science, commerce and art represents an artistic vision unhampered by conventional meanings or the purposes of art.

Katrina Moorhead was born in Coleraine, Northern Ireland and studied art at the Edinburgh College of Art in Scotland. She moved to the United States in 1996 to begin a Core Artist Residency at the Glassell School of Art. Moorhead was a 2005 resident artist at ArtPace in San Antonio and was selected to represent Northern Ireland at the 2005 Venice Biennale. Moorhead currently lives and works in Houston.

CJG

Someone Else's Salton Sea (Moonlite), 2001
Styrofoam, polymer clay, glitter, glue and paint, 5 x 12 ½ x 11 ½"
Purchase with funds provided by the Robert U. and Mabel O. Lipscomb Foundation Endowment

JESÚS BAUTISTA MOROLES
born 1950

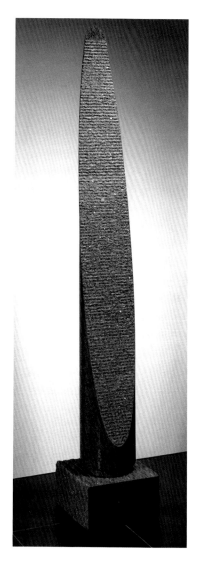

Jesús Moroles tames hard rocks. He enjoys the intensity of the process; having to wear protective gloves, using equipment that works the stone and becoming lost in his efforts to control design.

Scale and structure are essential to Moroles' compositions. *Ellipse* is an elegant reminder of modernist works like Brancusi's *Bird in Space*. The work is composed of granite from Italy and Texas. It has a rounded back that hovers at slightly larger than life size and the face is incised in horizontal, rhythmic bands. The sculpture works as a totem or a marker even as it resides within its strictly abstracted form.

Moroles has recently experimented with sound and movement in his work. His large kinetic pieces are meant to be touched and he likes to "play" his sculptures as one would a musical instrument. The oeuvre of Jesús Moroles is replete with exquisite works that reward contemplation.

Moroles studied at the University of North Texas, at El Centro College, Dallas. He apprenticed under Luis Jiménez in El Paso and has worked in the quarries of Piettrasanta, Italy. His work is in numerous private and public collections. Jesús Moroles lives and works in Rockport, Texas.

AG

Ellipse, 1990
Italian and Texas granite, 81 x 13 ½ x 13 ½"
Purchase with funds provided by the Friends of EPMA in honor of
Becky Duval Reese's 10th Anniversary as Director

CELIA ALVAREZ MUÑOZ
born 1937

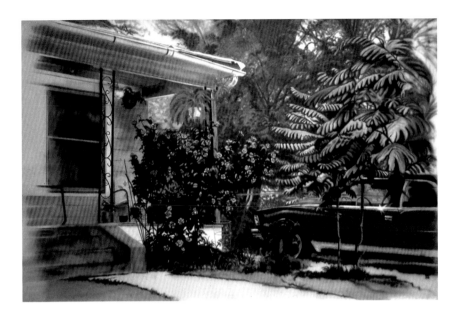

Rooted in the conceptual, Celia Alvarez Muñoz uses her art to explore identity and socialization through personal narrative. These works are part of Muñoz's charged *Postales* series, her first large, site-specific installation. According to Muñoz, *Postales*, "came from observing the effect of the Chamizal Treaty." The 1963 treaty formalized a long-disputed section of the border between Mexico and the United States. The result was the forced move of Mexican-American families from South El Paso into predominantly white neighborhoods.

The series explores the manifestation of these moves, as in *Naranja Dulce* with its vibrant orange-yellow house. In what she labels "territorial bravado," Muñoz comments that these families indicated their arrival by "painting their house[s] in happy and bright colors as they had been accustomed." The installed street signs (*El Paso/Il Peso* and *Myrtle/Muertos*) represent the literal intersection of English and Spanish language familiar to any Border resident. Muñoz states that they explore "the mispronunciation of English names by Spanish language speakers and the Spanish names mispronounced by the English language speakers."

Text-based scrolls in the series form a fictional narrative that personalizes the political. Installed here is, "One day Sarah who lived on Chihuahua Street wore an orange dress to the offering and everyone laughed. But she stayed on anyway." Like this fictional character who

Naranja Dulce (from the Postales series), 1988
Acrylic on canvas, 72 $^1/_8$ x 110 $^3/_4$"
Purchase with funds provided by the Robert U. and Mabel O. Lipscomb Foundation Endowment

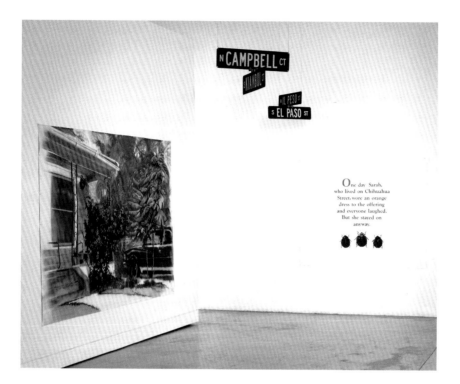

chooses to "stay on anyway" these works ultimately speak to the tenacity of ethnic groups in mainstream American culture. Although the series references a specific point in American history, *Postales* speaks to the delicate tension between cultural pride and gradual assimilation that is often central to American identity.

Celia Alvarez Muñoz received her BA from the University of Texas at El Paso and her BFA from the University of North Texas. Born in El Paso, she lives and works in Arlington.

BF

(from left to right)

Naranja Dulce (from the Postales series), 1988
Acrylic on canvas, 72 $^1/_8$ x 110 $^3/_4$"

El Paso/Il Peso and Myrtle/Muertos (from the Postales series), 1988
Painted metal street signs, dimensions variable

Ay! Chihuahua (from the Postales series), 1988
Acrylic on canvas, 57 $^3/_4$ x 72"

Purchase with funds provided by the Robert U. and Mabel O. Lipscomb Foundation Endowment

NICK MUÑOZ
born 1970

Spray paint is suffused with loaded political and social meaning, the weapon of choice for a generation of seminal Chicano muralists and guerilla street taggers. Nick Muñoz rejects these connotations in his paintings, approaching the medium in a highly formal manner. Muñoz's abstractions are elaborate systemic arrangements relying solely on a personal vocabulary of diagonals overlapping circles and the occasional square. Muñoz explains: "circles, squares, being basic are void of content. Geometric shapes are void of subject matter so I rely on their basic relationships to create an image that is for me aesthetically cohesive."

Often intimate in scale, Muñoz's paintings are spatially rich, amassed with hundreds of soft layers of paint. It is by this layered process, manipulating the weight of his medium by utilizing overspray and varied strokes that Muñoz achieves a shifting chiaroscuro. Stippling is built up to create sugary vitreous surfaces. Titles such as *White Grid* reveal both the mathematic underpinning of each composition and Muñoz's formal Modernist concerns. More importantly, Muñoz's titles, like his subject matter are objective. The subjective is allowed in only with color, but he relies on viewers to complete the work, stating that "people give scale, content, give usage to the work; colors and forms are primal, viewers react, can have their emotions stirred up."

Nick Muñoz received his BA from the University of Texas at El Paso. He lives and works in El Paso.

BF

White Grid, 2001
Spray enamel on canvas, 14 1/8 x 9 7/8"
Gift of the VC Gallery

AUDLEY DEAN NICOLS
1885-1941

"The so-called gray of the desert is a mistake. The desert is everything but gray. There are clean fresh blues in the skies, pinks and yellows in the sunset, opalescent purple, rose and lavender in the distant mountains, dull greens of every shade in the vegetation, and reds and yellows in the rock and earth—but never gray" writes Audley Dean Nicols who was born in Pittsburgh but lived the majority of his life in El Paso. Discovering the desert Southwest was a boon both to Nicols' livelihood and his health. Suffering a permanent crippling disease, described as "a tubercular hip," the dryness of the area agreed with him, and he realized that the desert landscape was to become his muse. Nicols had supported himself as an illustrator for *Harper's*, *McClure's* and *Collier's* but realized that magazine illustrators would soon be replaced by the developing technology of halftone engraving. The artist returned to school and focused on a new career as painter of desert views. By 1919, Nicols had moved his family permanently to El Paso, where he diligently worked producing his desert paintings.

Nicols became known for his ability to capture the strong clear light peculiar to the desert Southwest as well as the subtle yet plentiful desert colors. Nicols claimed that in order to capture the desired lighting of a specific place he had only 15 minutes to do so. In order to utilize the entire day, he worked on three canvases simultaneously: one canvas for early morning, one for mid-day, and one for evening. *Sunland Landscape* is quintessential Nicols. Classically structured with fore, middle, and background, Audley Dean Nicols translates to canvas his respect and love for the distinctive light of the desert Southwest.

BDR

Sunland Landscape, 1923
Oil on canvas, 11 1/2 x 19 1/2"
Gift of Mrs. W. W. Turney

NIC NICOSIA
born 1951

Nic Nicosia's video reflects more than twenty years of experience in photography as well as formal studies in radio, television, and film. Nicosia's first photographs were color interiors that he partially covered with construction paper to mix truth and fiction. In subsequent series, Nicosia added friends and family to his scripted, melodramatic frozen images.

In the video *Middletown*, Nicosia returns in real time to a concern that he investigated for years, the facade of middle-class suburban America. Weaving its way through Nicosia's Dallas neighborhood *Middletown* appears to be about an ordinary drive through an everyday American neighborhood, but things are not as they seem and the accompanying carnival music soundtrack only reinforces the peculiarity. After several times around the same streets the viewer begins to notice that a young child is actually pulling what appears to be a body behind his bicycle, meanwhile two tall Texans with cowboy hats stride confidently forward. The subtle questioning of Nicosia's video work typifies the Post-modern era of doubting "master narratives." Like many contemporary artists, Nicosia's recent work has also begun to explore the possibilities presented by emerging digital technologies.

Nicosia has exhibited his work in group exhibitions such as the Whitney Biennial (1983 and 2000) and Documenta (1992) as well as many other national and international exhibitions. His work is represented in numerous public and private collections.

CJG

Middletown, 1997
Video, 15 minutes
Gift of Mr. and Mrs. Dan Boeckman

KERMIT OLIVER
born 1943

Religious symbolism and stories from mythology inform the art of Kermit Oliver. Incorporating biographical elements that include self-portraits and images of family members, his works carry moral narratives based on human behavior and on stories that speak to issues of the human condition. Oliver's compositions rely on classical training that result in a "symbolic realism" which recalls the work of the Wyeths with an overlay of magical realism. Interweaving teachings from the Bible with his memories of life in south Texas, Oliver often presents morality plays enacted by friends and family that are accompanied by personal mystical symbols. In *St Elmo's Fire (Study)*, the artist creates a scene in which a lamb placed in the foreground is juxtaposed against a threatening tornado in the background. Oliver says of this frequently incorporated symbolism, "…I've always used the calf or the sheep as representative of a sacrificial animal alluding to those attendant mythological and religious attributes: the restorative and regenerative symbol of the theme of death, birth, and the transformation of the self." Framing his works to reference stained glass windows of church architecture derives from memories of his younger days in rural Texas. Regarding his art-making career Oliver also says, " Yet, the enterprise of making images, not like the flash of Saint Elmos's Fire of an earlier youth…continues to enthuse and impel me to continue such journeys and activities of discoveries."

Kermit Oliver grew up in the South Texas town of Refugio and studied art at Texas Southern University in Houston with John Biggers and at Rice University with Elaine de Kooning. Kermit Oliver's art has been shown in numerous group and solo exhibitions and his works are in collections throughout the state. He lives in Waco.

BDR

St. Elmo's Fire (Study), 1993
Acrylic on paper, 27 x 19"
Purchase with funds provided by the Robert U. and Mabel O. Lipscomb Foundation Endowment

(ROBERT) JULIAN ONDERDONK
1882-1922

Born in San Antonio, Julian Onderdonk was a precocious child who was educated mostly by his family at home. He was encouraged to paint and draw at an early age and by age 16 he was learning art techniques from his father, Robert Jenkins Onderdonk. By 1901 he was studying in New York at the Art Students League, taking summer classes with William Merritt Chase and night courses from Robert Henri. The teachings of Chase greatly influenced the young artist's desire to paint *plein air*. From New York he wrote his family: "I long to get out in the open air with my palette in one hand and brush in the other and be able to smear paint over the whole landscape."

Returning to San Antonio in 1909, Julian often joined his father on sketching trips where he made his "memory notes" that were later used in his studio to complete a painting begun outdoors. Julian Onderdonk brought a realistic approach to nature albeit with an impressionist's interpretation. His application of colors in short, powerful brushstrokes and his colors infused with light reflect the poetry of the state's varied landscapes.

Bluffs on the Guadalupe River 17 miles above Kerrville, Texas, a tour de force painting by the hand of a mature artist, reveals the Texas Hill Country in all its luminous fall colors where brilliant contrasts of sunlight and shadow are balanced by varied perspectives and elevations of the land.

BDR

Bluffs on the Guadalupe River, 17 miles above Kerrville, Texas, 1921
Oil on artist board, 9 x 12"
Purchase with funds provided by the Estate of Charles H. Leavell

ROBERT JENKINS ONDERDONK
1852-1917

Born in Maryland, Robert Onderdonk studied at the National Academy of Design in New York City and later at the Art Students League, which in 1875 he helped organize. He traveled to Texas in 1878 to visit friends and settled in San Antonio a year later where he raised his family by seeking commissions and teaching. Onderdonk's paintings record landmarks of San Antonio that include the Alamo as well as the other missions of the area and the third mill built in the town along with portrait studies and landscapes. *Buffalo Hunt* is a rare example of the artist's oeuvre. In this roiling, action-filled painting, Indians on horseback are depicted in their hunt for sustenance and shelter. Replete with cactus, cow skulls, and frenetic ponies, Onderdonk's picture works almost as a daily tabloid capturing the drama, staging, and thrills of a long ago time in the West.

Robert Onderdonk took *Buffalo Hunt* to the 1904 St. Louis Fair where it was purchased by a newspaper editor. The artist was father to a daughter, Eleanor, and a son, Julian, artists in their own right who also left their marks on the art of Texas.

BDR

Buffalo Hunt, circa 1898
Oil on canvas, 42 x 24"
Gift from the children of Jack H. Nelson in his memory

WILLIE RAY PARISH
born 1947

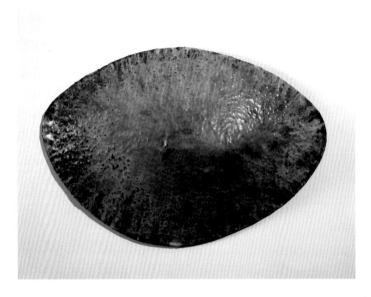

Appearing to be a completely abstract form with a complex, textured surface, most viewers don't realize why *Deep Dive* was created. One in a series of over fifty sculptures that reference sea mammals breaking the ocean's surface, Parish's *Humpbacks* indirectly speak about the artist's environmental concerns and his continuing interest in dialogue about the context of sculpture.

While Parish is best known as an abstract sculptor and often involved with public art projects, his work acknowledges its debt to Minimalism, but often has a layer of personal meaning as well. One of Parish's first series was a group of suspended abstract works that honored thirty friends who died before the age of thirty. The *Humpbacks* from the 1980s to the early 1990s have a more global meaning and evaluate the purpose of art. In the late 1990s, Parish experimented with endeavors such as a public art project that used grafted trees and a series of traveling sculptures utilizing Airstream trailers gradually transitioning to a new series of kinetic works involving the theme of danger. For example, in *Undeterred They Continued Driving South* from 2003, Parish crushed a piano into an Airstream trailer and added a soundtrack. Some of Parish's non-representational, kinetic works rely on the natural force of wind currents for their movement while others require viewer interaction.

Parish was born in Mississippi and cites his grandparents as early influences on his decision to become an artist. After working compulsively with his hands throughout high school, Parish went on to study at the University of Mississippi and then at the Otis Art Institute. For the past twenty years he has taught sculpture at the University of Texas at El Paso, has exhibited his work in exhibitions nationally and currently has public art commissions throughout the South.

CJG

Deep Dive (from the *Humpback* series), 1992
Brass, 35 x 42 x 10"
Purchase with funds provided by the Robert U. and Mabel O. Lipscomb Foundation Endowment

GLORIA OSUNA PÉREZ
1947-1999

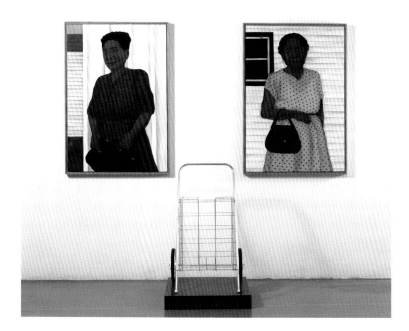

In formal Spanish, the title of this work translates to "the errand," but on the Border the term is a colloquialism for grocery shopping. *El Mandado* comprises portraits of Gloria Osuna Pérez's grandmother and her good friend, or *comadre*, flanking a two-wheeled wire cart. Ignoring its perception as a seemingly trivial domestic task, the artist instead presents grocery shopping as an important act of socialization for women of her grandmother's generation whose daily trips to the market involved gossip, social support, political debate, family counsel, and active involvement with the community around them. The cart acknowledges that the trip will be on foot and the artist writes that it "carries the substance of life," linked symbolically to the womb and the ceramic vessels of historic indigenous cultures of the American Southwest.

Although Gloria Osuna Pérez started as an artist in César Chávez's *Teatro Campesino* and works from a set of references pulled from Mexican and Chicano culture, her portraits seek the universal. Combining multiple people from her own life in single figures and highlighting the dignity in the ordinary, Pérez's portraits articulate archetypal bonds of family and community that stress the importance of women's relationships. She writes that she was compelled "to show people and their lives, emphasizing the positive, seeking the external reality, enlarging the reality into a universal scale that invites participation with the details."

Gloria Osuna Pérez was largely self-taught. Originally from Madera, California, she produced most of her work while living in El Paso.

BF

El Mandado, 1998
Acrylic on canvas and two-wheeled wire cart, dimensions vary
Purchase with funds provided by the Robert U. and Mabel O. Lipscomb Foundation Endowment

BURTON PRITZKER
born 1941

Regardless of their subject, Burton Pritzker's photographs reflect a formal elegance on paper. Three Pritzker photographs from the *Texas Rangeland* series exemplify his most well known body of work.

Instantly recognizable, the bull's horn implies danger as well as the bravery of the photographer. Pritzker states, "My work has always been about the experience I have when I look through the camera," thereby revealing the importance of "the photographic act" to Pritzker and stressing how different photography is from other art forms.

Burton Pritzker was trained in and practiced architecture. His earliest photographic work, the *Pathfinder* series of 1976, incorporates architectural forms as its subject matter. After producing eight series of varying subjects, Pritzker maintains that he "was always interested in the same thing, not the subject, but rather what lies below the surface." Pritzker demonstrates the influence of the modernists Alfred Stieglitz, Edward Weston, and Minor White, who are known for their use of photographic metaphors to show meaning derived beyond objective appearance. Pritzker shares with them a forté for finding poetic abstraction in recognizable subjects.

Pritzker was born in Chicago and earned his Bachelor of Architecture from the University of California at Berkeley. Pritzker has exhibited his photography since 1976 in group and solo exhibitions throughout the American Southwest including the Roswell Museum of Art; the Albuquerque Museum of Art; the Tucson Museum of Art; the Houston Center for Photography; the Grace Museum, Abilene; and at the Galveston Arts Center. His work is found in the collections of the Albuquerque Museum of Art; the Witliff Collection at Texas State University; the San Jose Museum of Art, California; the Harry Ransom Center at the University of Texas at Austin; and the Museum of Fine Arts, Houston.

CJG

Steer #7, Art, Texas, August 2000
Gelatin silver print, 12 x 8"
Purchase with funds provided by the Robert U. and Mabel O. Lipscomb Foundation Endowment

NADEZDA PRVULOVIC
born 1930

A chance encounter with a blast furnace some 20 years ago continues to guide Nadezda Prvulovic's creative investigations. Born in Dubrovnik, Yugoslavia, but living in France, Prvulovic spied an abandoned steel mill set in the rural landscape of Thionville. The artist recalls standing within the cavernous space and being overwhelmed by its scale. She internalized the power of its purpose and began to create large-scale works based on the fiery hot properties of molten steel. Prvulovic studies the shapes of these colossal structures, which she transforms through a melding of abstraction and color to stage dramas based on pure force.

In the studio, Prvulovic begins with collaged images that she transforms as they are applied to paper. She constantly seeks to destroy and cancel the gestures of her brushstrokes through layering, overlapping, or interweaving. Expanding her colors beyond the original reds and oranges, Prvulovic examines her own psychological responses to colors like pink, blue, or green while still working within the structure of the blast furnace. The combined results of her efforts produce powerful works of art that reveal Faustian aspects of the damned or the sublime exaltations of salvation. The art of Nadezda Prvulovic thrills, inspires, and challenges as it evokes questions regarding the nature and consequences of power. The artist lives and works in Richmond, Texas.

BDR

Blast Furnaces, 1992
Gouache on paper on canvas, 58 x 144"
Purchase with funds provided by the Robert U. and Mabel O. Lipscomb Foundation Endowment

PAUL HENRY RAMIREZ
born 1963

"Bubbles," "squirts," and "fizz" are not words typically associated with the visual analysis of a painting, but are helpful in describing the magically dynamic work by Paul Henry Ramirez, *Elevatious Transcedualistic #5*. The biomorphic, candy-colored shapes evoke Willy Wonka's factory or Dr. Seuss's world of intelligent nonsense. Of course, more serious art historical connections emerge: Paul Klee, Joan Miró, and Pop palettes from the U.S. and Japan. Yet such references fall short in describing Ramirez's distinct style and imaginative use of color and space. Defying the parameters of the canvas, Ramirez's paintings become a total environment. He paints organic forms that seem to morph into something other than a composition in paint.

Pinks, blues, greens, purples, and contrasting black lines bubble up and drip down, suggesting movement, sound, and vibrancy. Large and small areas of pure color, like drops of candy, appear among hair-like wisps of black. The palette is akin to patterned clothing of the 1970s that reflected trends in contemporary art. Patterns and playfulness are a part of Ramirez's visual vocabulary, but he achieves this playfulness with sophistication and reserve. Color sits on top of color without the suggestion of illusion or depth. Ramirez's work is visually intricate and without overt subject matter. He succeeds in creating a work that defies reality with imagination.

Ramirez studied at the University of Texas at El Paso and at the Raritan Valley College in Summerville, New Jersey. He has had several one-person shows, including those at the Rena Bransten Gallery, San Francisco; the Aldrich Museum in Ridgefield, Connecticut; and at the Whitney Museum of American Art's Phillip Morris Gallery, New York City. His work can be found in numerous public and private collections including the Aldrich Museum and the Whitney Museum of American Art.

AG

Elevatious Transcedualistic # 5, 2001
Acrylic, enamel, and flashe on canvas on panel, 24 x 96"
Purchase with funds provided by the Robert U. and Mabel O. Lipscomb Foundation Endowment

ROBERT RAUSCHENBERG
born 1925

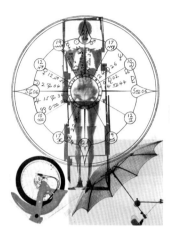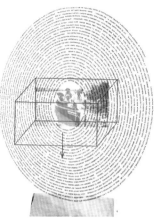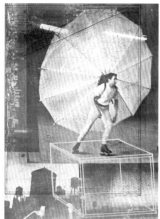

Perhaps no other artist asserted greater influence over the second half of the 20th century than Robert Rauschenberg. His work, appropriating ordinary imagery and objects not only established a bridge between Abstract Expressionism and Pop Art, but radically reassessed the strictures within which art could maneuver. This appropriation, along with Rauschenberg's use of mass media techniques and experiments in dance and photography, endowed a vernacular for almost every major movement since Pop Art. Robert Rosenblum has written, "every artist after 1960 who challenged the restrictions of painting and sculpture and believed that all of life was open to art is indebted to Rauschenberg—forever." Rauschenberg has consistently imbued meaning and resonance to the seemingly disparate mix of imagery and material he pulls from the everyday.

Autobiography is a triptych that can be displayed either vertically or horizontally and represents the first use of a commercial billboard press for a fine art print. Rauschenberg mines previous works and personal memories to create an unconventional self-portrait. The first panel uses the artist's full-body x-ray, originally used in 1967's *Booster*, printed over his astrological chart. The chart positions Rauschenberg's artistic status as predestined, the skeleton highlighting the body as the conduit for art-making. The middle panel features a childhood family portrait with autobiographical text spiraling around it. The last shows a photographic still from Rauschenberg's 1963 performance piece *Pelican*, over which a navigational chart and images of his hometown of Port Arthur, Texas and the New York City skyline viewed from the artist's studio are superimposed. Unifying all three panels compositionally are the three circles created by the astrological chart, spiraling text, and parachute strapped to Rauschenberg's back during *Pelican*. Embracing the mythic, each circle subtly functions as a *mandorla* or *nimbus*, visual devices used in ancient and medieval art to denote holiness and divinity.

BF

Autobiography, 1968
Color offset lithograph on three sheets, 66 ⅛ x 48" each
Gift of Marian B. Javits, Robert Rauschenberg and Milton Glaser;
Courtesy of the Yale University Art Gallery

FRANK REAUGH
1860-1945

"Art should be taught with the view of training both the vision and the mind, and especially the mind. It should be made as important a part of learning as mathematics. Study art, not to do, but to know, then it may be that what you do will be worth while," so advised Frank Reaugh (pronounced Ray) in a printed statement addressed "To My Patrons."

Born in Jacksonville, Illinois, Frank Reaugh was fifteen when his family moved to a ranch in Kaufman County, southeast of Dallas. By 1890, the bachelor Reaugh, had moved with his parents to the Oak Cliff section of Dallas where he and his father built the artist a studio and a second floor open-air "tower" where Reaugh slept. Largely self-taught, Frank Reaugh studied briefly at the St. Louis School of Fine Arts (1884-1885) and at the *Academie Julian* in Paris (1888-1889). His one trip to Europe introduced Reaugh to the work of many artists, but he was most affected by the work of Dutch artist Anton Mauve, whose art—landscapes and animals—validated Reaugh's chosen subjects: the Texas landscape and the Texas Longhorn. He knew the land and the cattle from first hand-observation since in the 1880s he had gone on roundups, followed the herds, and eaten and slept as the cowboys. It became Reaugh's practice to take his students on camping and sketching trips where he taught them to make their own pastels, observe the land and animals from nature, and live like cowhands. A devoted and loyal following maintained his studio for many years after his death.

Frank Reaugh produced over 7,000 works of art throughout his life. Land and cattle were his primary subjects, which he presented in an impressionistic style and with a palette of soft colors. He captured the mood and the light of the Texas landscape at various times of the day and seasons of the year. The two works in the Museum's collection are typical of the thousands of completed sketches he produced. Diminutive in their scale, the pastels elegantly capture the expanse and exquisite emptiness of 19th century Texas.

BDR

Untitled (Desert Scene, Long Mesa in Background), no date
Oil pastel on paper, 5 x 9 ¼"
Purchase with funds provided by the Estate of Carl and Vivan Hertzog through the executors of the estate, Dr. and Mrs. H.D.Garrett, and by the members of the El Paso Museum of Art

SAM REVELES
born 1958

Many talented children dream of being artists as adults, but El Pasoan Sam Reveles did not share that childhood dream. "Being an artist was something very remote to me because I didn't know any artists. It didn't seem like a real profession," comments Reveles. In 1981, he enrolled at the University of Los Angeles in pursuit of a degree in Graphic Design. It was there that a professor encouraged him to study painting instead. He soon returned home and received a BFA from the University of Texas at El Paso. Upon completion of his undergraduate studies, he attended the Yale University School of Architecture and Design and received an MFA in 1987.

After graduate school, Reveles moved to New York and later to London, where he was exhibited in a number of group and solo exhibitions. Even though he had to leave El Paso to pursue a successful career, his hometown still occupies an important place in his heart. From the titles he chooses for his art to the color schemes he selects, El Paso is prevalent in his prolific body of work. *Tigua* refers to the Tigua Indian reservation located in the lower valley of east El Paso, where Reveles was raised. This is one of the last series of paintings the artist completed before his final move from El Paso. The rich burnt sienna pigment and the expressive brush strokes are symbolic of the color and the rough texture of the arid desert landscape Reveles still considers home.

KM

Tigua, 1993
Oil on canvas, 57 ⁵/₈ x 85"
Purchase with funds provided by the Robert U. and Mabel O. Lipscomb Foundation Endowment

LINDA RIDGWAY
born 1947

Linda Ridgway's Instructions, probes the mind as to which is more real: image, concept, or object. In a complicated process that includes photography, appropriation, drawing, and bronze casting, Ridgway's work quietly and elegantly evokes multiple levels of meaning. On the left is a drawing from a photograph in a 1950s magazine of a silver basket with cigarettes sitting on a crocheted doily. The image represents a return to the artist's beginnings as it also hinges on a new direction, combining digital technology and found imagery. In a two by three foot area of dense vinyl text in the center of the work are the instructions for crocheting the doily depicted in the drawing, referencing Ridgway's conceptual work. To the right is the bronze manifestation of the doily, transforming image and text into a physical object more accurate in size and texture than either of the other parts.

Ridgway studied at the Louisville School of Art, and at Tulane University. During the 1970s and 1980s, whether Ridgway worked with sculpture, printmaking, installation, or drawing, the formal element of line referencing natural forms began to emerge in her work. In the late 1980s, she became interested in bronze sculpture and explored the infinite possi-

Instructions, 2004-2005, (detail 1)
Archival ink, graphite, vinyl and bronze, dimensions variable
Purchase with funds provided by the Robert U. and Mabel O. Lipscomb Foundation Endowment

make d tr in last tr made and in next tr, thread ove
holding back on hook the last loop of each d tr ma
made). Repeat from * once more, (ch 3, tr in same
3) twice; make a joint d tr as before. Repeat from
as last d tr make (tr, ch 3) twice; make a joint d tr
(ch 3, tr in next tr, ch 3, sc incenter of next ch, ch
next tr, ch 3, sc in center of next ch, ch 3, tr in ne
having first d tr in same place as sl st and 2nd d tr
tr, ch 3, make a joint d tr as before, ch 3, in same p
joint d tr as before, ch 3, in same place as last d tr i
in same place as last d tr make (tr, ch 3) twice. Re
rnd to correspond. Join. 7th rnd: Ch 7, sc in joint
tr, ch 3, sc in next joint d tr, ch 3, tr in next tr, ch
oval as before. 8th rnd: Ch 9, (tr in next tr, ch 5) ‹
sc, and complete rnd to correspond. Join (46 sps).
next tr) 15 times; (ch 5, tr in next sp) twice; ch 5 i
correspond. 10th rnd: Sl st in each st to next tr, sl
next tr, tr in next 5 ch. Repeat from * around, en‹
tr in next 9 tr) twice; (ch 8, skip 2 tr of next group
with ch 5, sl st in top of ch-4. 12th rnd: Sl st in ne
ch 5, tr in next sp, ch 5, tr in next sp ch 5, skip 2 t

bilities of lost-wax bronze casting of natural objects. The transformation of natural and human-made objects such as leaves, roses, and grapevines has since become a hallmark of her style. Linda Ridgway has exhibited in many group and solo exhibitions at galleries and museums. In 1999 she was awarded the Texas Artist of the Year prize. Her work is in collections throughout the United States, including the Dallas Museum of Art, the Modern Art Museum of Fort Worth, and the Museum of Fine Arts, Houston.

CJG

Instructions, 2004-2005, (details 2 and 3)
Archival ink, graphite, vinyl and bronze, dimensions variable
Purchase with funds provided by the Robert U. and Mabel O. Lipscomb Foundation Endowment

DAN RIZZIE
born 1951

When Dan Rizzie is printmaking he is perfecting his ability to combine numerous visual elements, often emphasizing surface and texture into aesthetically pleasing collaged images. *Untitled* is such an image, with its many bold, graphic parts including organic forms like flowers and cellular shapes in addition to geometric forms like circles and rectangles. Rizzie's subject of choice is the floral still life full of vitality. Rizzie is well known for his skillful and seductive printmaking as well as for his personal iconography utilizing semi-abstract, black silhouettes and primary colors. He has a preference for collaging chine collé elements such as bits of weathered newspaper, old documents, and personal letters into his prints to juxtapose the past with the present.

Rizzie first gained recognition for his hard-edged, cubist, and constructivist-inspired abstract paintings and collages when he lived in Dallas in the 1980s. In the 1990s he moved to New York City and then to Sag Harbor, New York and began to work seriously with printmaking until it became his preferred, signature medium.

Rizzie was born in Poughkeepsie, New York and spent his youth in countries such as Egypt and India, where his father worked in the foreign service. He received his MFA from Southern Methodist University. His paintings, prints, and collages have been included in exhibitions across the country for the past twenty-five years. His work is represented in the permanent collections of the Museum of Modern Art and the Metropolitan Museum of Art, New York City, the Dallas Museum of Art, the Museum of Fine Arts, Houston, and many corporate and private collections throughout the United States.

CJG

Untitled, 1994
Monotype with chine collé, 96 x 48"
Purchase with funds provided by the Robert U. and Mabel O. Lipscomb Foundation Endowment

RILEY ROBINSON
born 1961

According to Aristotle, "the aim of art is not to represent the outward appearance of things, but their inward significance." Riley Robinson's work, coalescing conceptual ideas with a deep physical affinity for material, consistently reveals that inward significance. Robinson has worked in a number of varied media, but insists that each new experience requires careful attention to respect the integrity of the material. Linking his work in conventional art media like wood, metal, and ceramic to the non-traditional like lawn chairs, is what he defines as an "interest in craft, craftsmanship, handiwork."

Like other sculptures by Robinson, Untitled (Salt and Pepper), maintains a strong physical presence that adheres to a sense of human scale. Semi-figural, both parts of the work mirror each other; Riley playfully juxtaposes heavy welding seams with the polished wood strips. Untitled (Salt and Pepper) elegantly represents Riley's fascination with duality, a theme that he frequently explores. The title playfully alludes to binaries that essentially operate in terms of relativity: masculine and feminine, light and dark, idiosyncrasy and uniformity.

Riley Robinson received his BFA from Virginia Commonwealth University and his MFA from the University of Texas at San Antonio. He currently lives and works in San Antonio.

BF

Untitled (Salt and Pepper), 1993
Plywood and steel, 71 ³/₄ x 26 x 25 ¹/₂" each
Purchase with funds provided by anonymous donors in memory of
John Jay Scott and Florence Steele Scott

MARGO SAWYER
born 1958

A child of the world, Margo Sawyer was born in the United States, brought up in England, and traveled extensively throughout her growing years. Frequent trips to the Middle East, Asia, and Africa etched upon her young mind images and sensations she would later draw upon in her art. The artist recently said: "Throughout my career, I have devoted much time to the observations of the major historic and contemporary sites of sacred architecture. I am particularly interested in how the relationships between space and transcendence functions, where architecture and ritual converge in creating installations that instill contemplation ... my work has revealed a commitment to creating spaces that focus on an equivocal nature of space, where installation art, architecture and time converge."

Much of Sawyer's work involves room-sized floor installations where the viewer is surrounded by controlled light, sound, and objects. The pieces evoke quiet introspection and are cerebral exercises in meaning. In *Index for Contemplation #16* Sawyer works in a smaller, more individualized scale. She incorporates a simple geometric and color vocabulary to elicit an aura of the sublime.

Margo Sawyer received her BA from Chelsea School of Art in London and her MFA from Yale University. Committing herself to art in Texas since 1988, she is currently a member of the faculty at The University of Texas at Austin where she lives and works.

BDR

Index for Contemplation #16, 2005
Powder coated steel and aluminum, 101 x 53 x 6"
Members' Choice Purchase

URBICI SOLER
1890-1953

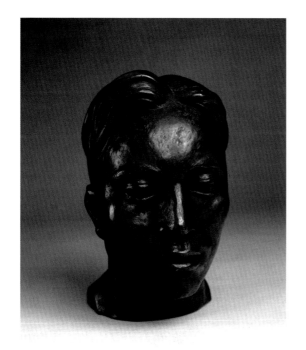

Classically trained sculptor and educator, Urbici Soler vigorously opposed Modernism's move towards abstraction. Although frequently stylized, his works are emphatically centered on the figural. Born in Spain, Soler began apprenticing at age 10 in the studio of a Barcelona sculptor. Distinguishing himself, in 1913 Soler won a scholarship to study in Munich, an important artistic center that at that time was a popular alternative to training in Paris. He briefly taught in Munich before traveling throughout Europe, spending time in various sculpture ateliers, including that of Rodin's chief assistant, Émile Antoine Bourdelle.

In 1925, Soler traveled to Argentina where he spent five years creating public works in Buenos Aires. While in South America, Soler was commissioned by the Spanish government to create portrait busts of various indigenous people of South and Central America, including the Tarascans, Mixtecs, Zapotecs, and Aztecs. *Head of a Boy* most likely resulted from the extensive traveling necessary to complete this project. Soler made his way to the United States in 1931 when the busts were exhibited at the California Palace of the Legion of Honor in San Francisco. Unable to return to Spain in 1937 due to the civil war, Soler reluctantly accepted the commission for a monumental Christ statue. The artist's best-received work, *Cristo Rey* is a 40-foot cruciform work installed on the El Paso mountain peak *Sierra de Cristo Rey*. Plagued by funding problems, Soler's vision for *Cristo Rey* was ultimately limited. After more travel, Soler eventually settled in El Paso, teaching at the College of Mines (now the University of Texas at El Paso) and becoming a fixture in the region's artistic dialogue with friends Tom Lea, Peter Hurd, and Manuel Acosta.

ABP

Head of a Boy, 1935
Bronze, 12 x 7 x 9 1/2"
Gift of Mr. and Mrs. Cliff Hildegass

AL SOUZA
born 1944

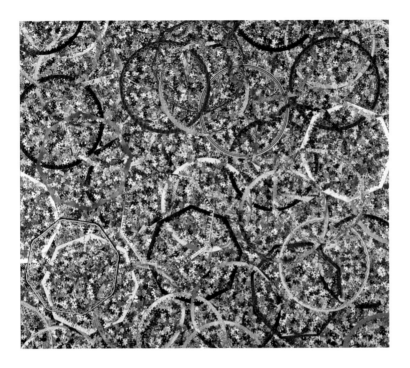

Al Souza's work in photography, painting, and assemblage is informed by conceptual principles. Souza's interest in visual culture and how it is distilled into everyday life results in playful, intuitive appropriation of imagery and material. In the last decade, Souza has turned to the world of puzzles to create collages of lyrical coherence and baroque proportions. Much has been made of these works' reliance on chance. Although seemingly incidental, Souza carefully orchestrates each composition addressing in his work a variety of painterly concerns: color, balance, structure.

Beginning with secondhand puzzles (purchased assembled), Souza selects a unifying subject, theme, or color. Loose pieces and completed chunks are mixed, stacked, and adhered in dense layers. Due to the inherent imagery of puzzles, stock landscapes, cartoon characters, and banal still-lifes, the completed works frequent the representational. *Cogs and Wheels'* decided bent towards abstraction results from the decision to keep the periphery of less common rounded puzzles intact.

Al Souza received a BS in Civil Engineering from the University of Massachusetts, Amherst. He attended the Arts Students League and returned to Amherst for an MFA in painting. He lives and works in Houston.

BF

Cogs and Wheels, 2003
Puzzle parts and glue on wood, 72 x 84"
Purchase with funds provided by the Robert U. and Mabel O. Lipscomb Foundation Endowment

GAEL STACK
born 1941

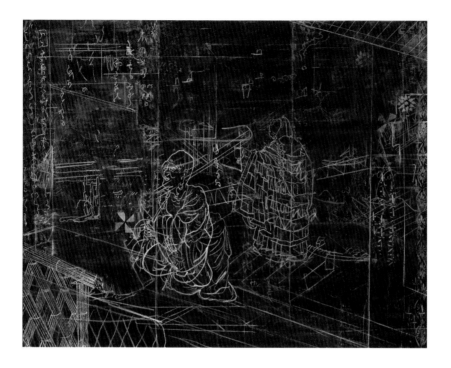

Dense compositional structure, multiple pictorial layers, overlapping text, repetition, and obliterations fuel the deceptively chaotic paintings of Gael Stack. Stack's "blackboard paintings" present an alternative form of potent communication that addresses both transience of memory and limitations of language.

Over monochromatic grounds, Stack employs imagery appropriated from Western and Eastern art historical sources. Stenciled symbols, architectural drawings, equations, bits of calligraphic text and incorporated phone messages, shopping lists, and other miscellany are worked over each other. Carefully controlled and initially enigmatic, these seemingly unrelated mixes of information provoke more than a casual reading.

In the late 1960s, Stack began using personal narrative as a departure point for her works, but consciously avoiding literal depiction. Among its layers of imagery, *The Watchers* features Buddhist priests pulled from Chinese art and boats, a recurring symbol that the artist uses in many works. In discussing this work Stack states, "I am kind of an anxious person, *The Watchers* is about the possibility of not danger but uncertainty; being apprehensive, paying attention to the disquieting, mild warnings, things that hint about wrong."

Gael Stack studied at the University of Illinois, Urbana-Champaign and at Southern Illinois University. She lives and works in Houston.

BF

The Watchers, 1993-94
Oil on canvas, 60 x 76"
Purchase with funds provided by the Robert U. and Mabel O. Lipscomb Foundation Endowment

EARL STALEY
born 1938

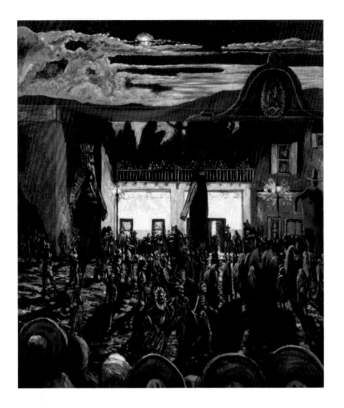

Earl Staley's art derives its form and content from the Texas landscape, Mexican folk art, and biblical and mythological themes. His narrative works tell their stories through symbols interwoven by an expressive realism. Three works in the Museum's collection demonstrate several of the artist's interests. Beginning in the mid-1960s, Staley made numerous camping trips to Big Bend National Park. While camping, he often studied the land by creating watercolors of it. *Tornilla Creek, Big Bend, Texas* represents the artist's true-to-nature renderings that result in a somewhat traditional landscape painting.

The Temptation of St. Anthony exemplifies Staley's interest in selecting a theme, in this case a story from the Bible, and working and re-working the idea through numerous prototypes. Narrative and composition become operatic in Staley's hands as issues of good and evil and life and death are investigated in bold colors and bravura brushwork. *Parade* evinces the artist's interest in Mexico and the Mexican culture. Beginning in 1975, Staley's frequent travels to Mexico resulted in his establishing a studio outside the city of Oaxaca where he lived and worked for a period of time. The use of religious symbolism and ritual observances by local artists influenced Staley's subject matter, which is reflected in the painting.

Staley was born in Chicago and received degrees from Illinois Wesleyan University and the University of Arkansas. He moved to Houston in 1966 to teach at Rice University. Living in and out of Houston since that time, the artist has also lived in New York City and Rome.

BDR

Parade, 1991
Acrylic on canvas, 55 ¼ x 47 ½"
The Barrett Collection, Gift of the Museum of Fine Arts, Houston

ANN STAUTBERG
born 1949

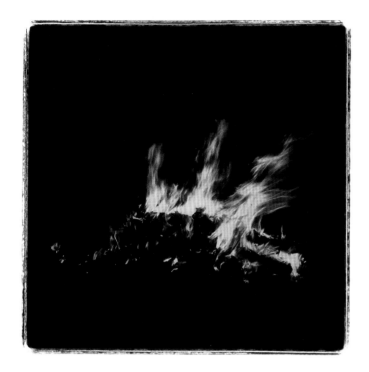

Blurring the boundaries between painting and photography, Stautberg's work conveys the idea that a camera, like a brush, is just one of the tools available to the artist. Stautberg is well known for her subtle, large format, hand-colored photographs. Her largest series of these were taken along the Texas Gulf Coast (1991-2001) and specifically seek to convey a specific sense of place. Each photograph in this series has a documentary character as it is inscribed with the date and time the image was made at the bottom of the work. Stautberg does not distort the photographs through her painting, but rather paints her photographs to more vividly evoke memories of the photograph's particular time and place.

At first glance, 3-22-96, P.M., *Texas Coast*, appears to be a large color photograph of a raging bonfire at night. In fact, it is a black and white gelatin silver print that the artist skillfully painted with translucent layers of oil paint to capture an annual event held with the artist's husband, Frank X. Tolbert—the burning of that year's unsuccessful artworks.

The fact that Ann Stautberg started out as a painter and printmaker cannot be over-emphasized when considering her work because her latest series of works, the *Oriental* project, not only continues but also expands upon the *Texas Coast* series with a shift towards greater abstraction.

Stautberg studied painting and printmaking and received a BFA from Texas Christian University and an MA from the University of Dallas. Her work is in the collections of the Dallas Museum of Art, the Modern Art Museum, Fort Worth, and the Museum of Fine Arts, Houston as well as in many private collections. Stautberg currently resides in Galveston.

CJG

3-22-96, P.M., Texas Coast, 1997
Gelatin silver print with oil paint, 56 x 50"
Purchase with funds provided by the members of the El Paso Museum of Art

JAMES SURLS
born 1943

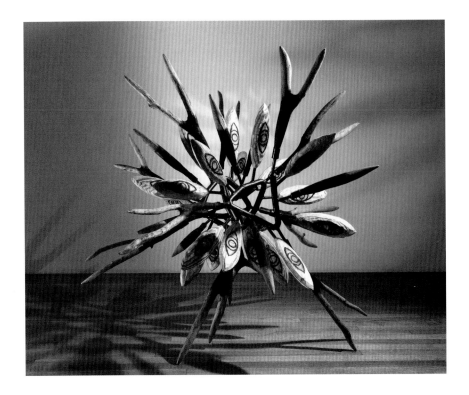

The magnitude and force in the work of James Surls emanates from his soul. Perhaps the ultimate romantic, the art he creates draws on his thoughts, experiences, and of course, his feelings. Surls looks inward to convey notions about love, family, and connectedness. Expressing his ideas through his individually conjured visual alphabet—symbols he uses and reuses—narratives emerge that reflect universal concerns. Riffing on aspects of the sublime, the artist turns to his native roots both for inspiration and for materials.

Born in Terrell, Texas, the piney woods are home to him and for years served as his primary muse. Living for 20 years in Splendora, Texas (40 miles northeast of Houston), Surls culled the fallen trees, examined their limbs, and looked for the stories their shapes could tell. In 1997 he and his family left Texas for Colorado, but his poet's vision continues to find protean forms of expression.

Surls relies primarily on three subject categories for his art: flowers, birds, and the human figure. The sculpture *Me As Walking Eye* offers the chance to decipher the meaning of his

Me As Walking Eye, 1985
Oak, pine and steel, 49 1/2 x 55 x 47 1/2"
Gift of Jean W. Bush in memory of Gerald W. Bush

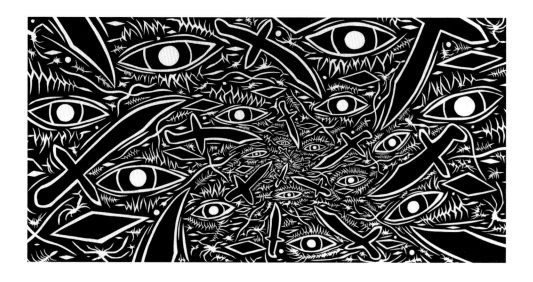

work through the titles, which are bridges to understanding. In this work, the natural wood with its burned, blackened areas is held together with cold steel that conveys beauty coupled with danger. In the oversized woodblock print *Through It All*, the visual alphabet provides once again an opportunity for decoding. The print incorporates eyes, knives, diamond shapes, and stylized scorpions. With close scrutiny and some amount of intuition, viewers can look deep into the heart and mind of this artist of southern sensibilities and pass on his dreams.

BDR

Through It All, 1990
Woodcut on paper, 48 x 96"
Purchase with funds provided by the Robert U. and Mabel O. Lipscomb Foundation Endowment

EUGENE THURSTON
1896-1993

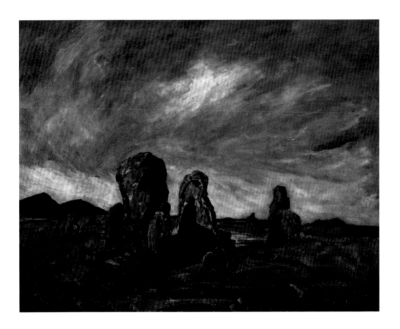

Eugene Thurston, a largely self-taught artist, chose the desert Southwest as his primary subject matter. The artist once said: "I love the desert just the way it is in its most dramatic moments...spectacular moments of bright color and...restful mood of soft color." Like his colleague, Audley Dean Nicols, Thurston painted what he observed and focused closely on observing the landscape about him. Thurston was born in Memphis, but moved to El Paso when he was nine. His mother, Fern Thurston, was also a painter who no doubt influenced her son. After graduating from high school, the artist studied commercial art through correspondence with the Federal School of Art based in Minneapolis. Thurston studied with other artists and worked prolifically, teaching himself through practice. Even into his eighties, the artist created at least six paintings per month. Thurston earned a living through teaching art from 1940-1966 at El Paso Technical Institute and El Paso High School. He was a member of numerous art groups and frequently participated in juried group exhibitions. City of Rocks, a work that at first glance seems a surreal image derived from deep within the psyche is in reality a rendering of an actual place. City of Rocks State Park (a two hour drive from El Paso) is a geologist's fairyland. Gigantic monoliths were spewed forth as volcanic ash millions of years ago and through thousands of centuries cooled and congealed to form behemoth boulders. The giant rocks amaze travelers who observe these stone leviathans rising from the surrounding flatlands. Eugene Thurston captures on canvas a natural wonder and depicts the scene in an expressionist style. Thurston who chose throughout his career to focus on the land reveals in City of Rocks a mysterious place of the present that records a geologic past.

BDR

City of Rocks, 1949
Oil on canvas, 24 x 30"
Gift of Holly and Sanford C. Cox, Jr.

OLIN HERMAN TRAVIS
1888-1975

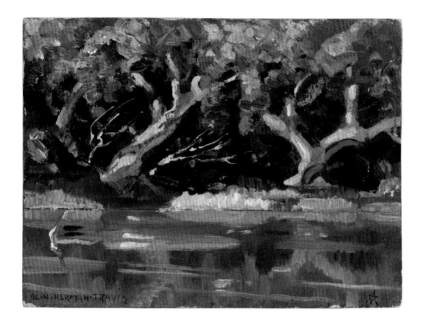

Texas-born artist Olin Herman Travis was an important voice in the fledgling Dallas art scene of the 1920s. A graduate of the Art Institute of Chicago, Travis had studied with the respected painter Kenyon Cox. Teaching for a brief period at the Art Institute and then serving as director of the Chicago Commercial Art School, Travis was experienced and adept in the administration of art schools. He returned to Dallas with his artist-wife Kathryn Hail Travis, and together they founded the Dallas Art Institute in 1924. By the 1930s, Travis was regarded as an elder statesman among the Dallas-area artists whom he employed to teach and who included Jerry Bywaters, Alexandre Hogue, and Thomas Stell. These artists, among others, embraced a "new regionalism" style of painting and were instrumental in its spread throughout the state. Through the Dallas Art Institute many significant artists began their studies, for example, Everett Spruce, Florence McClung, William Lester, and Charles T. Bowling. In *Reflections in the Concho*, Travis's bravura brushwork reads bold and assured. His penchant for *plein air* painting is evident in this oil study that captures impressions of the fall colors of cottonwood trees along the banks of the Concho River, which runs through San Angelo. Olin Herman Travis was a skilled and prolific painter. He was widely exhibited during his life and his commitment to the education of younger artists was crucial to the strength of the arts in Texas.

BDR

Reflections in the Concho, circa 1918-1930
Oil on panel, 6 x 8"
Collectors Circle Purchase

LÉON TROUSSET
circa 1838–1917

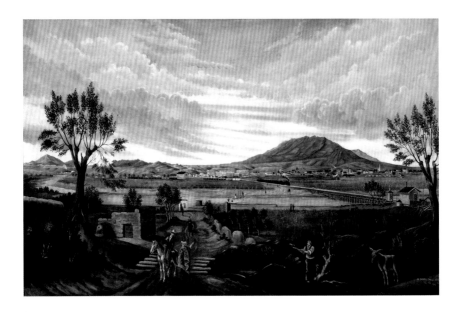

Despite scarce historical sources, it is known that French-born Léon Trousset was an itinerant painter of landscapes and urban scenes. A number of scholars hypothesize that Trousset may have left Europe for Mexico as part of Napoleon III's ill-fated French Intervention. The first records of his presence in Texas date to 1867, the same year French forces evacuated Mexico. The forty-two existing works by him chronicle travels throughout the Southwest and northern Mexico. In each city he visited, Trousset painted familiar local scenes for both patrons and bidders at local sales. Trousset eventually settled in the El Paso-Juárez region, married, and adopted a son. Believed to be self-taught, Trousset's sophisticated handling of atmospheric details and strong compositional sense hint at some formal training in France.

His 1885 *View of El Paso* is a detailed look at the city from across the Rio Grande in Cuidad Juárez. Careful attention is paid to the Franklin Mountains as well as local landmarks such as Union Depot, First Baptist Church, and Ft. Bliss. A locomotive steaming past the center of the work documents El Paso as a hub for three major railroad lines, a visual reminder of the source of prosperity and a tremendous population boom. Two versions of the work were executed; the Museum's version was commissioned by a Mrs. Anna McNeil. The other, now lost, was sold in the artist's typical fashion. A notice in *The El Paso Daily Times* from January 23, 1885 reads, "A fine oil painting of El Paso, the work of Leon Frousset [sic], will be raffled at the Acme Saloon: 60 chances, one dollar each. Let everybody see it."

BF

View of El Paso, 1885
Oil on canvas, 39 x 60"
Gift of Mr. and Mrs. J. Sam Moore, Jr. and family

CHARLES UMLAUF
(born Karl Julius Umlauf) 1911-1994

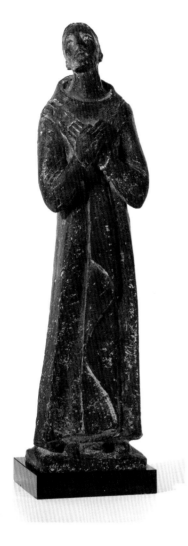

A third grade teacher saw talent in the young Charles Umlauf and in 1921 enrolled him in the free Saturday classes at the Art Insitute of Chicago. Orphaned by age 14, Umlauf worked as a busboy, dishwasher, and golf caddy. He subsequently received scholarships to study at the Art Institute and the Chicago School of Sculpture. The artist worked on Federal Art Projects until 1941 when he received an invitation to join the faculty at the University of Texas at Austin. For the next 40 years, Charles Umlauf taught sculpture at UT-Austin, retiring as professor emeritus.

Throughout his long teaching career, Umlauf was also widely exhibited and collected. His works are held by museums throughout Texas and the United States. Umlauf's public sculptures are on view at Love Field, Dallas; the Witte Memorial Museum, San Antonio; in Austin at the University of Texas; and in Lubbock. The Austin home and studio of Charles Umlauf is now open to the public as the Umlauf Sculpture Garden. Of his art the artist said: "I start with the spirit of the thing and my own feeling about the essence of life. I sketch a plan on paper for execution of the work...although as the work develops, I may change it to satisfy my feeling." *Padre*, a work of 1961 is a classic example of the artist's style. The simplified, abstract forms of the figure combine with the gestures of crossed hands and uplifted head to express the feeling of sincere spiritual devotion. Charles Umlauf worked hard throughout his life. He was a survivor and the volume of the art he produced stands as testament to an indefatigable soul who sought to express his ideas of life, love, and eternity through his art.

BDR

Padre, 1961
Bronze, 29 1/2 x 6 x 7 1/2 "
Gift of the El Paso Art Museum Association, Ann Butterfield Newman Memorial Fund Purchase

VINCENT VALDÉZ
born 1977

The American figurative tradition remains an essential part of our visual vernacular. Like many contemporary artists, Vincent Valdéz explores themes of identity and culture within this tradition. In *Rubio*, heightened realism produces a visual drama. The lone figure is cast in a theatrical glow of reds and oranges. Valdéz's unique style often incorporates the illusion of artificial light in interiors such as taverns or honky-tonks. In some cases he casts this same suggestive neon or reddish glow in exterior works. The graffiti mural serves a dual purpose, defining both the figure and the landscape. The echo between person and place creates a singular atmosphere. While tattoos and piercings are still taboo for some members of the population, others acknowledge them as fashion. The character of *Rubio* exhibits a strong sense of individual identity. This work captures a particular person at a particular moment, and Valdéz is successful in creating a cinematic tension of expectation. The diagonal perspective also adds an element of uncertainty. With gritty realism, he explores the struggles of the individual. Valdéz's portraits reflect his interest in identity and he states, "The strongest man in the world is he who walks alone."

Vincent Valdéz studied at the International Fine Arts College, Miami and at the Rhode Island School of Design. He lives and works in San Antonio.

AG

Rubio, 2003
Pastel on paper, 19 1/2 x 25 1/2"
Purchased with funds provided by the El Paso Museum of Art Foundation Endowment

WILLIE VARELA
born 1950

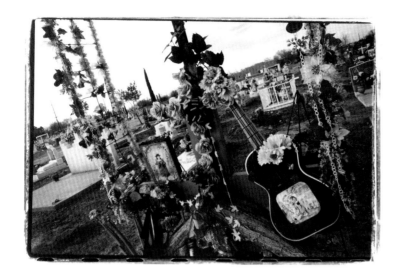

From crumbling sculptures of Christ amid scattered tombstones to anonymous passersby in advertisement-saturated urban settings, the photography of Willie Varela responds in a personal way to the culture found along the U.S.-Mexico border. Varela is well known as an innovative Border filmmaker and videographer who has also experimented with photography throughout his career. An early influence on both mediums was Robert Frank, the Swiss photographer turned filmmaker. Coincidentally, Varela's photography overlaps his film and video work in several ways. In both mediums Varela is a self-taught practitioner who probingly investigates his Mexican-American heritage and the influence of Hollywood and consumerism on American culture.

The Museum holds eighty-three Varela photographs encompassing several series from thirty years of work. However, in order to understand more about Varela's photography one should examine the largest series that Varela has worked on simultaneously through the years. Ambling through Mexican and American cities and cemeteries, he has carefully built a body of photographs that express his doubts about Catholicism as well as the implied alienation found in crowded urban areas. Capturing the everyday strangeness and beauty of city life in all its splendors, Varela's street photographs reveal his humanity as they comment on contemporary society. His solitary cemetery photographs on the other hand, display his empathy for others and the differing Mexican and American concepts of death. The chromogenic print *Socorro*, TX, differs slightly from his earlier cemetery photographs in that it depicts a well-kept grave of someone loved.

Varela was included in the Whitney Biennial in 1993 and 1995. In 1994 his film and video work was the subject of a retrospective exhibition at the Whitney Museum of American Art, New York City. During 2002-2004 Varela was the subject of a traveling retrospective exhibition titled *Crossing Over*. The artist lives and works in El Paso.

CJG

Socorro, TX, 1997
Chromogenic print, 30 x 44"
Gift of the artist

KATHY VARGAS
born 1950

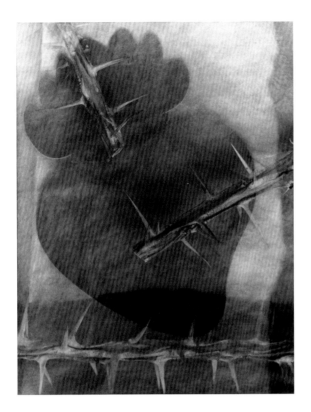

Kathy Vargas is known for her poignant "magical realism" photographs that incorporate memories from her childhood with culture and female-specific imagery. Vargas was born in San Antonio and after high school became active as a photographer of rock and roll bands. After brief study at San Antonio College with Mel Casas and participation in the Chicano arts organization *Con Safo*, Vargas produced some of her earliest artworks, photographs of yard shrines in east San Antonio. Vargas then studied photography at the University of Texas, San Antonio and received her BFA and MFA degrees in 1981 and 1984.

Vargas' technique often involves taking black and white photographs, printing single or multiple exposures, and then hand-coloring or using hand-written texts in a fusion of autobiography and allegory. Vargas returns to many of the same images and objects such as hearts, flowers, *milagros*, birds, masks, and skeletons in her photographs and installations because they have symbolic importance for her. The *"A" Series* #13 is part of a series related to dualities surrounding the beauty of a rose and the danger of its thorns and themes such as love and death and pain and suffering.

A dedicated arts activist, Vargas has worked to promote understanding of important social and political issues like censorship and AIDS. From 1985 until 2000 Vargas was the director of visual arts at the Guadalupe Arts Center. In 2002 Vargas became the chair of the Art Department at Incarnate Word University in San Antonio. She has been in numerous group and solo exhibitions at prestigious institutions including *Sala Uno* in Rome. In 2000 the McNay Art Museum in San Antonio held a thirty year retrospective of Vargas' work. Her work is in private and public collections around the country.

CJG

"A" Series #13, 1994
Photographic mixed media, 25 ¹/₂ x 20 ¹/₂"
Gift of Mr. Joe A. Diaz

CASEY WILLIAMS
born 1947

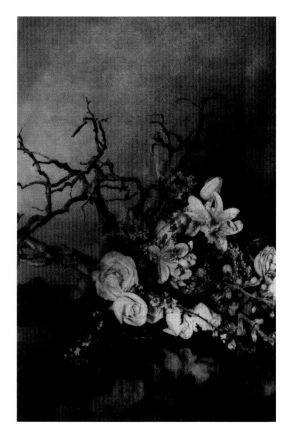

In the photogravure *Texas Landscape* I, a bouquet of roses and lillies in the foreground, and the twisted, dead branches and looming smokestack ambiguously protruding through a foggy, background sky, present a paradox of natural beauty and post-industrial reality that haunts the viewer.

The veiled subtlety of Williams' image is one of the hallmarks of his painting, printmaking, and photography. A similar double-edged character of multi-layered meaning is found through his past and most recent work. For example, in a 1995 black and white untitled photograph on canvas with acrylic, also in the El Paso Museum of Art collection, Williams double-exposed one frame of film to juxtapose an expensive chandelier with a modern factory interior in order to evoke reflection of the relationship between the two. In a more recent series, Williams refined his technique using digital technology to photograph the vibrant colors of rusted, painted ship hulls and their reflections in water, outputting them as almost life-size on canvas. Much of Williams' work investigates the uneasy relationship between painting and photography that has existed since photography began to threaten the need for painters soon after its invention.

Williams was born in Houston and currently lives there. In 1970 he earned a BFA from the University of Texas at Austin and in 1976 an MFA from the San Francisco Art Institute. Since the mid-1970s his work has been included in solo and group exhibitions throughout Texas and the United States. His works are in the collections of the Museum of Modern Art, New York City; the Bibliotheque Nationale, Paris; and the Museum of Fine Arts, Houston.

CJG

Texas Landscape I, 1995
Photogravure on paper, 26 x 19 ¹/₂"
Purchase with funds provided by the Robert U. and Mabel O. Lipscomb Foundation Endowment

ROGER WINTER
born 1934

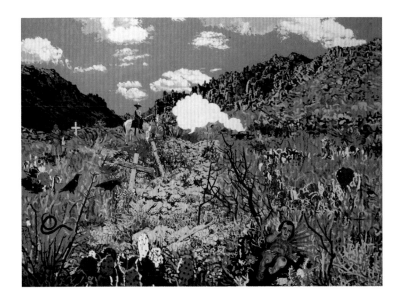

"I was born a photo-realist, or at least I can't remember a time when I didn't draw from photographs," wrote Roger Winter in 1997. Winter's oeuvre varies through the years from oil and acrylic paintings to cut paper and ink collages and drifts from complicated and intricate landscapes to straightforward unembellished portraits. Winter's work has also been identified as surreal. In his paintings random objects, animals, and humans coexist haphazardly. In *Devil's Garden*, a *vaquero* (cowboy), a laughing dog, several religious icons, and a flaming car with its own thought-bubble, all inhabit the same space, but do not seem to reside in the same plane of existence. There are many reoccurring images in his paintings from this period: the full moon, a jumping fox, disembodied fire, and bare wintry trees, to name a few. The repetition and perceived fascination with these objects begs further explanation. Winter theorizes, "I identify with the literary style of the Latin American realists like Gabriel García Márquez and his contemporaries."

Winter served on the faculty of Southern Methodist University's Meadows School of the Arts from 1963 until 1989. His former students include John Alexander, David Bates, and Dan Rizzie. Says Bates, "Roger Winter is right in the middle of an evolutionary chain of Texas artists that includes William Lester, Everett Spruce, Otis Dozier, Jerry Bywaters and on to Roger who then passed the bottle on down to a whole group of artists of which, I must say, I had more than a sip." He has published two books, *On Drawing* (1992) and *Introduction to Drawing* (1982).

Roger Winter was raised in Denison, Texas and earned his BFA from the University of Texas at Austin and his MFA from the University of Iowa. After spending several years in Maine, Winter now lives and works in New York City.

MDR

Devil's Garden, 1990
Oil on canvas, 62 x 82"
Gift of the artist

BEN WOITENA
born 1942

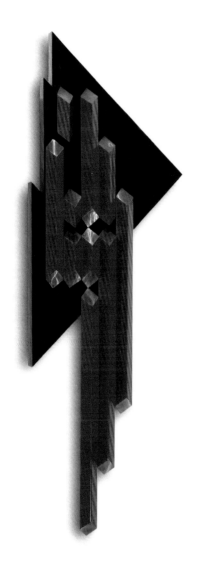

Ben Woitena works large. He enjoys the physicality of pushing steel I-beams around and in the process converting cold metal into new realities. Coming of age with the heroic acts of abstract expressionist artists, Woitena and his art could not be better matched. In his lumberyard converted studio, large-scale equipment—joists, pulleys, machines that cut and bind—is found. The challenge of manipulating these materials can be as satisfying as their end results. But the sculptures emanating from Woitena's workshop are most often like poems on the nature of transformation. Working with geometric shapes that are often coupled with filigree forms or shapes up-ended or set on point, the artist also incorporates color to set apart the contours of the metals. In *Antara*, he offers a starting point on the object's meaning. The word *antara* refers to a musical instrument once used by the Incas. Aided by this information, it is not a far reach to imagine the abstracted shapes forming a lyre-type instrument. There is frozen power to *Antara*. Its colors of stainless steel, gray, and red play on our consciousness and conjure notes of a long ago past.

Woitena was born in San Antonio and studied at the University of Texas at Austin where he received his BFA and at the University of Southern California where he received his MFA. The artist has exhibited widely and his work is in collections across the country. Woitena lives and works in Houston.

BDR

Antara, 1981
Welded painted steel and stainless steel, 108 x 36 x 8"
Gift of José F. Teran and Maria L. Teran

DEE WOLFF
born 1948

Dee Wolff uses her art as a deeply personal means of spiritual exploration and semiotic communication. Wolff distills what she calls the "common denominators" of comparative religious philosophy and psychology to examine the inherent need for consciousness. In 1976, she began working on a series of paintings titled *Selah*, a Hebrew word for the silent pause between the musical lines of a prayer. Since beginning this series, Wolff states that "all of my work in some way has been connected to *Selah*, before that to the idea of *Selah*."

The primary inspiration for *Selah* is the Catholic ritual of the Stations of the Cross, a cogitative set of 14 prayers focusing on Christ's last steps towards His crucifixion. Wolff deviates from an orthodox depiction by including a fifteenth station to represent the resurrection. Jewel-like colors over black ground imbued with sacred meaning in medieval manuscripts and art dominate these cohesive and sonorous abstractions. Each of the canvases that comprise *Selah* explores different approaches to pattern and color but is anchored by centrally placed crosses. According to Wolff, these crosses are used as reminders that every moment of existence should be treasured and that no two moments can ever be the same. As in many of her other works, *Selah* extracts influences from ancient Christian art, rituals from the middle ages, alchemy, eastern iconography, and meditation practices and the *Kabbalah*, a book of Jewish mysticism. Although the series germinated as a personal exploration of Christ's steps to the cross, *Selah* is really meant to mirror the viewer's own path to awareness and happiness. As Wolff writes, *Selah* is "a spiritual map representing an ancient and human psychological journey to the 'other' which exists within each of us."

Dee Wolff received her BA from the University of Texas at Houston and studied further at the Museum of Fine Art, Houston's Glassell School of Art. Born in Springfield, Minnesota, Wolff lives and works in Houston.

BF

Selah, 1978, (detail of 3 panels)
Acrylic on canvas, 15 panels at 11 3/8 x 9" each
Gift of the artist in honor of Clint Willour

SYDNEY YEAGER
born 1945

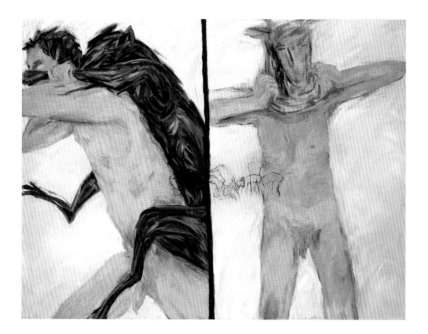

Sydney Yeager's oeuvre represents a conscious arc towards abstraction. Employing a highly personal lexicon of symbols particular to the organic, her work navigates the deep psychological struggles of human cognition. Of paramount interest is the tension between order and chaos and the tenuous dialogue between the two in everyday life, motifs that play out constantly in her works.

In the angst ridden *Uneasy Companions*, Yeager divides the painting in half, slashing a black diagonal in the middle to form a diptych. The struggle between order and chaos is illustrated on the left in the form of a physical conflict between a male figure and a wild dog and on the right through a figure wearing an animal mask. Yeager's love of the physical act of painting is evident in the tactile, thickly-worked surfaces of her canvas. The open brushwork and hazy atmospheric effect display Yeager's interest ebbing towards spontaneity and away from literal representation. Yeager overlays more figures, small and tightly drawn on a secondary scrim floating on the surface, a device she uses to create psychological tension and ground her works solidly in the figural. Two years after this work, Yeager moved away from representational painting, remarking that "from that point, the figure started getting lost." More recent works have abandoned the scrim and embraced full abstraction.

Sydney Yeager received her BA, BFA, and MFA from the University of Texas at Austin. She lives in Austin and paints in her studio in Elgin, Texas.

BF

Uneasy Companions, 1987
Oil on canvas, 60 x 78"
Bequest of the estate of Tré Arenz

ACKNOWLEDGMENTS

The Museum is grateful to the Dallas-based Summerlee Foundation and the El Paso Museum of Art Foundation for ensuring that our story is published and shared throughout the state. Donors to the Museum's Texas collection are many and the Museum recognizes and thanks each of you for enabling the collection to grow. Gratitude is also extended in particular to Museum staff for their insightful catalogue essays and to those who came before them who have dedicated their careers and countless hours to the El Paso Museum of Art in order to create this catalogue, one of the finest art museums and permanent collections in the country.

The El Paso Museum of Art, its physical plant and administration is made possible through the dedication of the City of El Paso and its Quality of Life and Museum and Cultural Affairs Department staff. In particular Debbie Hamlyn and Yolanda Alameda, directors of those departments respectively, as well as City of El Paso Manager Joyce Wilson and Mayor John Cook have provided great leadership and support of the arts in the City and at the Art Museum. Special thanks are extended to the El Paso Museum of Art Foundation for its vital partnership and encouraging the research and publication of the Museum's holdings, the El Paso Museum of Art Advisory Board and our membership, without whose support the Museum's programs would carry less meaning and significance to our community.

Michael A. Tomor, Ph.D.
Director, El Paso Museum of Art